# DETROIT REVEALED

Detroit Revealed

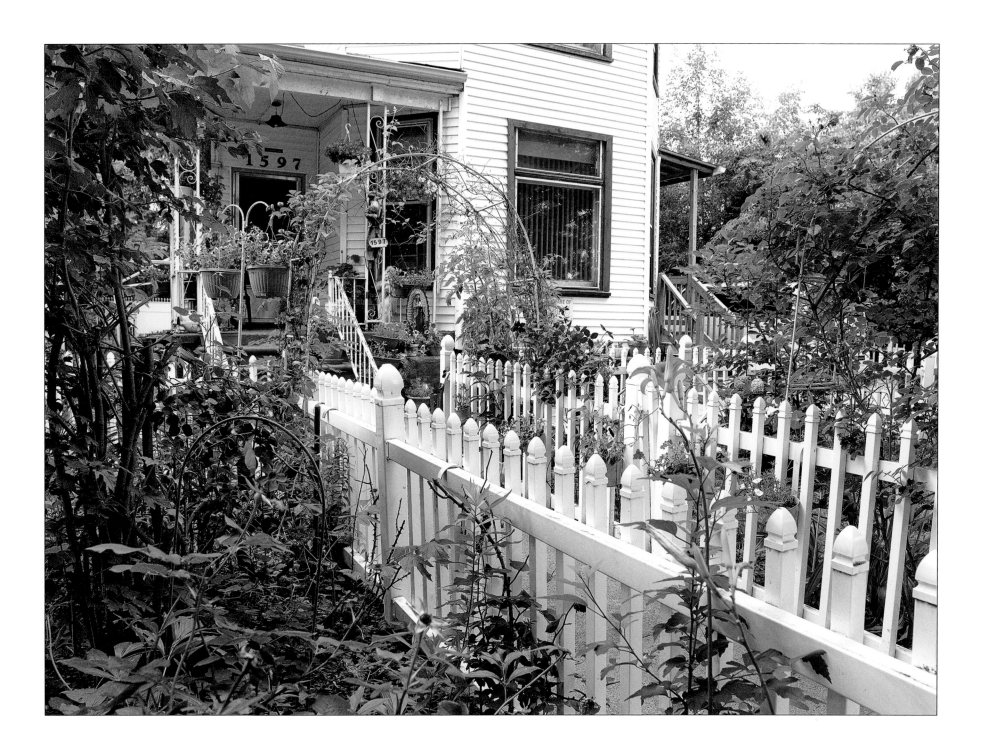

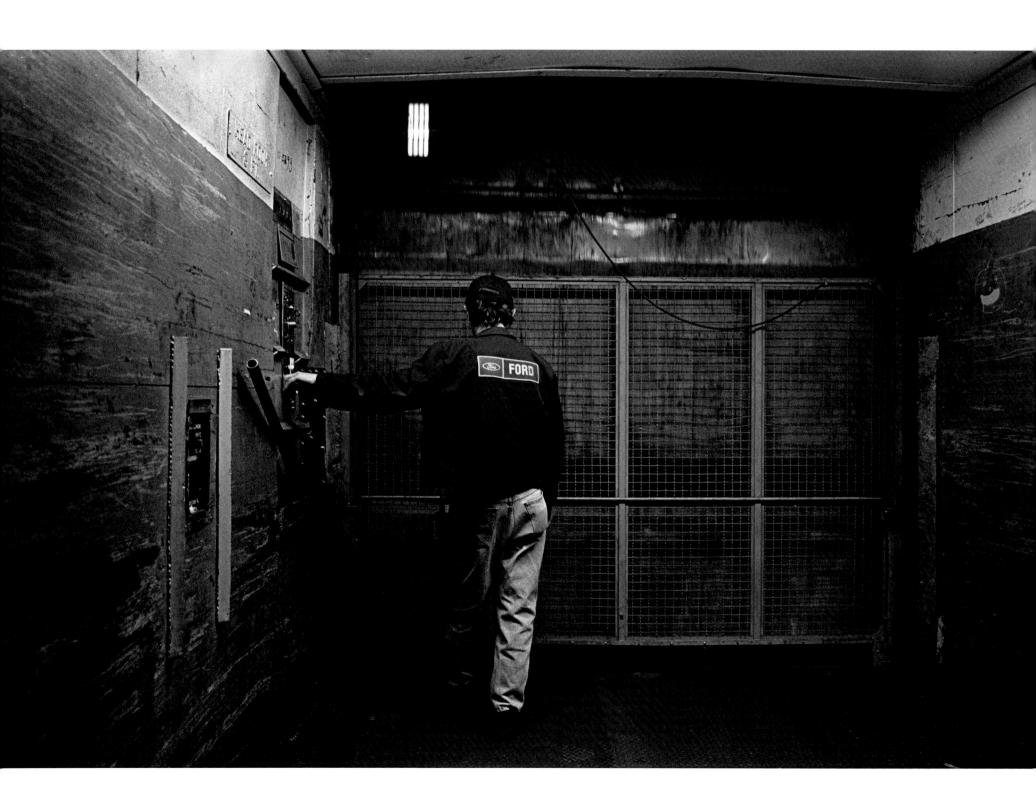

Detroit Revealed

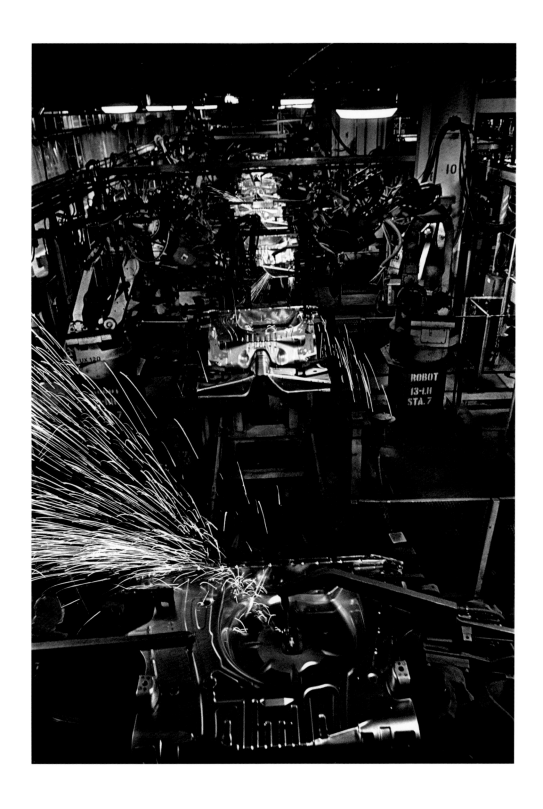

Detroit Revealed

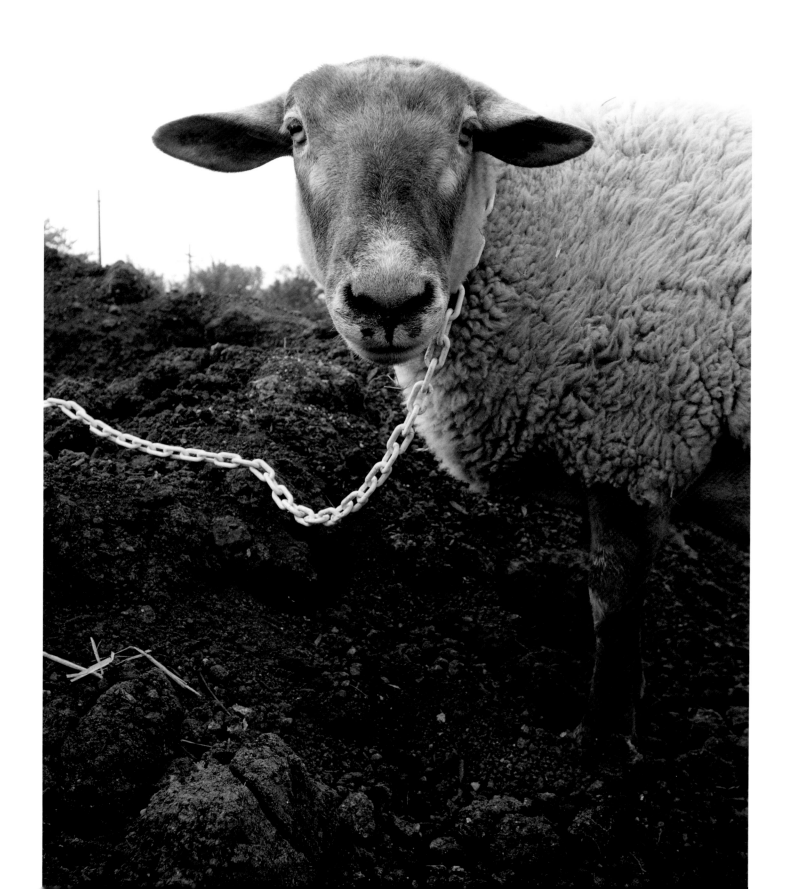

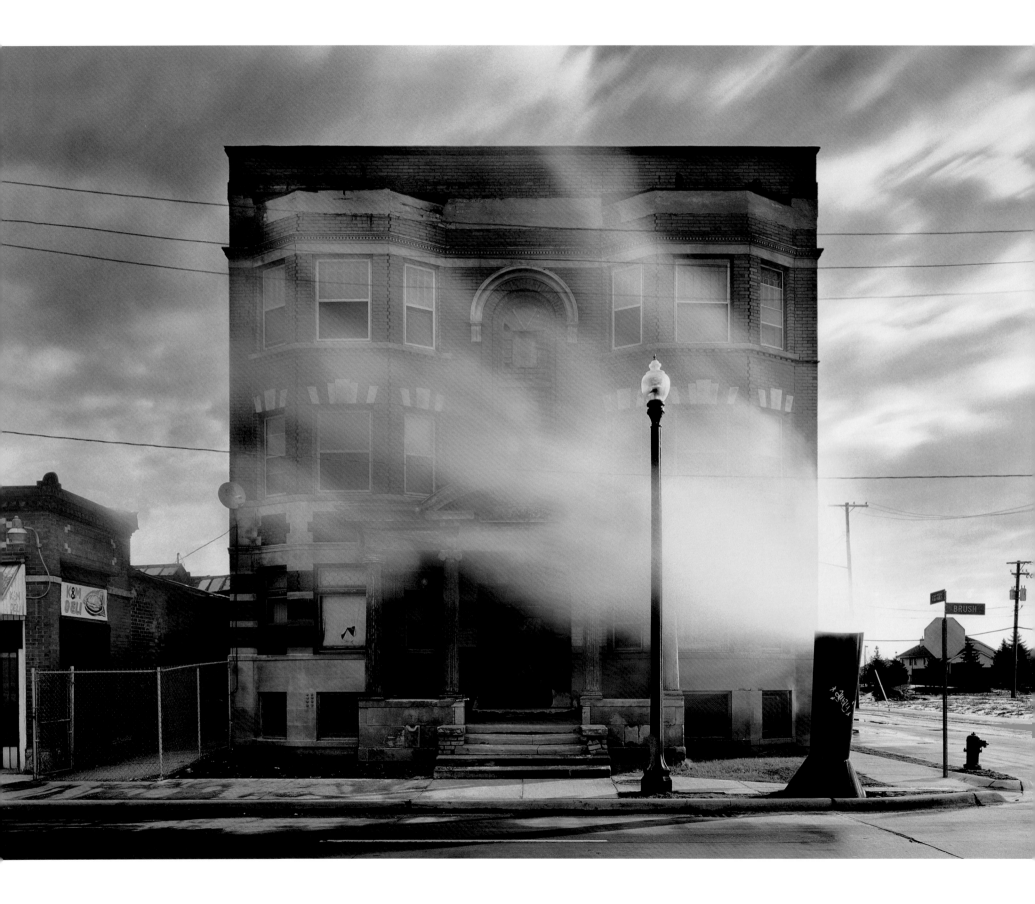

Nancy W. Barr, John Gallagher, and Carlo McCormick

Detroit Institute of Arts, Detroit

# DETROIT
# REVEALED

## PHOTOGRAPHS, 2000—2010

This catalogue was published in conjunction with the exhibition
*Detroit Revealed: Photographs, 2000–2010*

Detroit Institute of Arts, October 16, 2011–April 8, 2012

The exhibition was organized by the Detroit Institute of Arts.
Support has been provided by the City of Detroit.

The catalogue has been supported by Furthermore: a program of the J. M. Kaplan Fund.

Published by the Detroit Institute of Arts
5200 Woodward Avenue
Detroit, MI 48202
www.dia.org

Director of Publications: Susan Higman Larsen
Director of Photography: Robert H. Hensleigh

Edited by Susan Higman Larsen
Proofread by Tracee Glab
Designed by Savitski Design, Ann Arbor, MI
Printed and bound in Singapore

Measurements are given in inches, followed by centimeters. Height precedes width.

All photographs are in the collection of The Detroit Institute of Arts, unless otherwise noted. All photographs are courtesy of the artist, unless otherwise noted:

  Andrew Moore, pages 8, 61–63: courtesy of the artist and Yancey Richardson Gallery.
  Alec Soth, page 65: Magnum Photos

*Library of Congress Cataloging-in-Publication Data*

Barr, Nancy (Nancy Watson)
  Detroit revealed : photographs, 2000–2010 / Nancy W. Barr, John Gallagher, and Carlo McCormick.
    p. cm.
  Includes bibliographical references.
  ISBN-13: 978-0-89558-163-1 (alk. paper)
  ISBN-10: 0-89558-163-9 (alk. paper)
  1. Detroit (Mich.)—Pictorial works. 2. Photography, Artistic—Exhibitions. 3. Photography—Michigan—Detroit—Exhibitions. 4. Photography—Michigan—Detroit—Catalogs. I. Gallagher, John. II. McCormick, Carlo. III. Title.
  F574.D42B37 2011
  977.4'340222--dc23
                                        2011022395

DETROIT INSTITUTE OF ARTS

# CONTENTS

# DIRECTOR'S FOREWORD

It sometimes seems that wherever I go in the world—from London to Buenos Aires—I'm asked existential questions about Detroit. There always seems to have been some recent piece of coverage in one or another media outlet that restates the same old question (more often than not with a sizable dose of *Schadenfreude*): can this once mighty industrial hub survive in our purportedly "postindustrial" society? Detroit's towering ruin of a railroad station has taken on the iconic status of a latter-day coliseum; residential city blocks are depicted as prairieland in the making. There is, of course, no denying this aspect of early twenty-first-century Detroit, but the greater Detroit region is still home to more than four-and-a-half million people, and considerable thought, effort, and resources of all kinds continue to be focused on various revitalizations. As the "Midtown" area encompassing the Detroit Institute of Arts, with its plenitude of cultural institutions, research hospitals, and a thriving university clearly represents the most promise, it seems particularly apt that we present *Detroit Revealed*, an exhibition that shows a more nuanced and (dare I say it?) accurate picture of the state of affairs in Detroit today. Seen through the eyes of eight photographers—some resident, others not—Detroit today becomes a multifaceted endeavor. We see not just the endlessly aired pictures of failure, abandonment, and despair, but also images that speak of continuity, reinvention, and abiding love.

The idea for *Detroit Revealed* originated with the DIA's Associate Curator of Photographs, Nancy Barr, and I would like to express my great appreciation for the effort and care she put into organizing the exhibition as well as preparing the accompanying catalogue. All the works in the exhibition are recent acquisitions for the permanent collection, carefully selected by Nancy. A number of these works were donations from the artists themselves; others were purchased from funds donated by DIA patrons whose long-term support has been an all-important factor in the creation of our collection of photographs. We are grateful for their ongoing generosity. Finally, I would like to thank Swarupa Anila, head of interpretation, who collaborated with Nancy on the presentation of the exhibition in the DIA's Albert and Peggy de Salle Gallery of Photography.

**Graham W.J. Beal**
Director

# PREFACE AND
# ACKNOWLEDGMENTS

A gift of curatorial work is sometimes found in the realization that through research and study of a given subject and body of material, a revelatory form of art practice made by deeply enlightened individuals is revealed. This is the case for the work that appears in this book and for which research began nearly a decade ago. In 2001 I interviewed Robert Frank, who had traveled to Detroit in 1955 to photograph for *The Americans*. Frank found Detroit to be "unique" and "real," and his perceptions informed a methodology that would serve to unravel the complicated—and even peculiar—nature of the city through the medium of photography. With his work, Frank established a foundation for a photographic art practice in Detroit that looked beneath the surface of its then booming automotive industry toward a more critical representation of its people, places, and pastimes as defining of American experience. To Robert Frank and the other artists and photographers whose work appears in *Detroit Revealed: Photographs, 2000–2010*, I am thankful to have had a window into their perspectives, intuition, and motives for creativity that they have generously shared with me over the years. It has been my privilege to better understand the world and, in particular, the complex nature of Detroit through their eyes.

This book and the exhibition that accompanies it would not have been possible without the efforts and great passion of Michele Andonian, Dawoud Bey, Carlos Diaz, Scott Hocking, Ari Marcopoulos, Andrew Moore, Alec Soth, and Corine Vermeulen—eight individuals who, through their exceptional work, have contributed to a contemporary image of Detroit. Their photographs will serve to illuminate the city's unique character and complexity for generations to come. It is an honor for the Detroit Institute of Arts to present their work together for the first time and particularly at this critical juncture in the city's history when its physical, social, and cultural transformation has become the subject of national and international attention, as well as the subject of an overwhelming number of photographers.

Additional thanks are in order for the contributing authors John Gallagher and Carlo McCormick, who have eloquently lent their perspectives on the subject of Detroit to this publication. This book and exhibition refer to the first decade of twenty-first century Detroit, and it seemed appropriate to include city resident and *Detroit Free Press* journalist Gallagher, whose timely book *Reimagining Detroit: Opportunities for Redefining an American City* was published at the decade's end in 2010. Seeing opportunity in its shrinking population and vacancy, John looks beyond the city's vast decline to Detroit as "the world's biggest laboratory for trying out new urban ideas," as he notes in his essay. New York–based arts writer Carlo McCormick sees Detroit as a staging ground for a "new urban mythology" and a "new American narrative." I first met Carlo when he visited Detroit to write about the local art scene for *Paper* magazine in 2000. He had experienced the gentrification of his own downtown New York neighborhood by emerging artists in the 1980s and tried to convince me nearly ten years ago that a serious art community was on the rise here and would grow dramatically because of the city's unique postindustrial character. I thank him especially for our continued dialogue about Detroit, photography, and contemporary art, and for his additional prodding and encouragement that inspired me to research and write about Detroit-based work and artists.

I appreciate the hours and attention given to the realization of this book by many individuals who have provided support and invaluable assistance. The editing and production of this publication was thoughtfully guided by DIA Director of Publications Susan Higman Larsen, whose patience and attention was endless and exemplary. Thanks are also due to Mike Savitski and Kevin Woodland of Savitski Design for their sensitivity in the design of this book and the presentation of the photographs. Other DIA staff were instrumental in their contributions and support. They include Robert H. Hensleigh, director of photography, and Eric Wheeler, museum photographer, for their management of the digital files and reproductions in the publication; Christina Gibbs, registrar, for her organization of information and records related to works reproduced in this publication and found in the DIA's collection; Maria Ketcham, head librarian, and interns Nicolet Elert and Tracy Singer, for their assistance in obtaining necessary materials for research; and Devon Parrott, intern in the Department of Prints, Drawings, and Photographs, for preparation of the bibliography. Special thanks are also extended to Director Graham W. J. Beal, Executive Vice President Annmarie Erickson, Manager of Exhibitions Amy Hamilton Foley, and Curator of Prints, Drawings, and Photographs Nancy Sojka for their support.

**Nancy W. Barr**
Associate Curator
Department of Prints, Drawings, and Photographs

Nancy W. Barr

# IDENTITY MANAGEMENT: PHOTOGRAPHY AND TWENTY-FIRST-CENTURY DETROIT

The invention of photography, in 1839, was nearly simultaneous with the rise of the modern city. Paris, the first major metropolis of the Industrial Age, was the first to undergo extensive documentation by nineteenth-century photographers, who captured its transformation from a medieval into a modern city.[1] Once compared to Paris because of its tree-lined boulevards and grand architecture, present-day Detroit, for better or worse, has now captured the imagination of national and international photographers. Plagued by vacancy, depopulation, and blight, the city is a symbol of a failed America Dream. The demise of Detroit, represented most often by abandoned buildings and urban prairies, has been the most common subject of photographers. But this picture forms a singular narrative, one that some believe constitutes a new genre of photography specific to Detroit.[2] And although this picture of the city exists, one of its inhabitants, their voices, and its culture is largely absent. Intended as a corollary visual statement, *Detroit Revealed: Photographs, 2000–2010* offers recent imagery inspired by the complex identity of this remarkable and once industrious city.

*Detroit Revealed* is not meant to be a definitive survey of Detroit photographs or photographers. The eight artists were selected for their diverse and critical perspectives, ability to uncover what lies beneath the surface of life in Detroit, and the importance of city to their artistic practice. In their work, Detroit is seen as a challenging place of dramatic transformation. Like the city, these photographs are a deliberately eclectic and sometimes contradictory mix, from portraits to architectural studies to documentary reportage, with subjects ranging from the factory to the community farm, to the neighborhoods and their ethnic enclaves. This exhibition attempts to provide new windows into the experience and meaning of Detroit in the first decade of a new millennium, as well as to set new standards for a diverse and critical photographic practice grounded in the unique character of the Motor City.

### DETROIT, 1927-99: ESTABLISHING A CITY ICONOGRAPHY, A BRIEF HISTORY

Detroit's modern identity, like its economy, has been linked almost exclusively to the automotive industry. From the early to mid-twentieth century, the Ford Motor Company's Rouge complex in Dearborn, Michigan, was the primary signifier of all that was and is Detroit. Upon its opening in 1927, "The Rouge," as it was known, became a symbol of the American entrepreneurial spirit. Designed by Detroit architect Albert Kahn, the unique complex was touted as a fully self-sufficient manufacturing operation, as all the necessary raw materials were brought in to allow an entire automobile to be built on site. Travelers came the world over to see automotive production firsthand at the Ford plant.

From 1927 to 1955, artists Charles Sheeler (1883–1965), Walker Evans (1903–1975), and Robert Frank (born 1924), among others, traveled to the city to photograph at the legendary complex.[3] Sheeler's 1927 photographs of the plant, informed by the dramatic scale, clean beauty, and line of the machines, are considered an important part of the modernist aesthetic that was fashionable in the early twentieth century (fig. 1).[4] Workers were rarely seen in Sheeler's awe-inspiring images of the pristine factory, which, in actuality, was a massive, gritty, dangerous, and impersonal environment. The laborers at the Rouge became part of the world's largest working middle-class society, a culture new to the twentieth century and one that thrived in Detroit. In 1946, *Fortune* devoted its November issue to labor, including a two-page spread by Walker Evans. Using a hidden camera, Evans photographed a "Saturday afternoon in Downtown Detroit" that he published in a series of photographs featuring average men and women. A decade

later, in 1955, Robert Frank traveled to Detroit to photograph for a series that would become his iconic book *The Americans*.[5] Frank was one of the few photographers who saw the uniqueness of the city and its residents as a vital part of his story on American life. Through his photographs he gave visibility to everyday people, specifically African Americans, whom he frequently saw and acknowledged on the streets, on the assembly lines, and at leisure in Detroit parks and other public places. By this time, however, the concept of the American Dream had begun to erode, and Frank's photographs clearly show the social alienation, class struggle, and racial segregation present in the city and elsewhere in America.

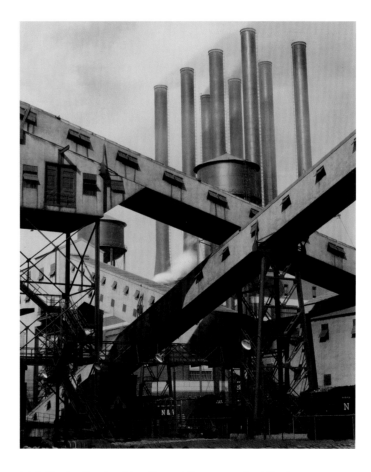

fig. 1. Charles Sheeler, *Criss-Crossed Conveyors—Ford Plant*, 1927, gelatin silver print, 10 x 8 in. (25.4 x 20.3 cm). © The Lane Collection. Courtesy, Museum of Fine Arts, Boston

From the late 1950s through 1980s, the changing appearance of Detroit, its so-called local color, and places and people evocative of particular historical eras were of interest to Detroit-based photographers, as well. Of particular note is documentary photographer and influential educator Bill Rauhauser (born 1918), who amassed an archive containing thousands of images made in Detroit between 1950 and 1980.[6] Finding inspiration in the streets, bustling store fronts, and shopping districts of the past, he also saw the true spirit of the city and its people in everyday diversions, such as local amusement parks, Shriners parades, and the annual auto shows that had become routine and beloved pastimes for Detroiters (fig. 2). By late 1980, Rauhauser had influenced an entire generation of Detroit-based photographers, but many of

his students as well as other local practitioners of the medium had discovered an entirely different Detroit.[7] They captured the city, its depressed neighborhoods, and creeping decline in a stark black-and-white documentary tradition that would serve to further a challenging image of the city that had desperately tried to rebrand itself after the 1967 riots as a "renaissance" city.

The riots of 1967 were not Detroit's first, but their long-term impact—along with depopulation, suburban sprawl, and the ailing automotive industry—has greatly influenced the image of the city for the last four decades.[8] Civil unrest caused by continued tension in the white and black communities was evident as early as 1943, when riots erupted over segregated housing. The photographs of Detroiter Arthur Siegel (1913–78), who was instrumental in providing documentary work while on government assignment for the Works Progress Administration, provide a chronicle of the problem of racial segregation in Detroit neighborhoods in the 1940s. Twenty-five years later, as neighborhoods continued to decline, local

fig. 2 Bill Rauhauser, *Untitled*, ca. 1960s, gelatin silver print, 12½ x 18⅝ in. (31.75 x 47.38 cm). Gift of Bill Rauhauser in memory of Doris Rauhauser, 2008.347

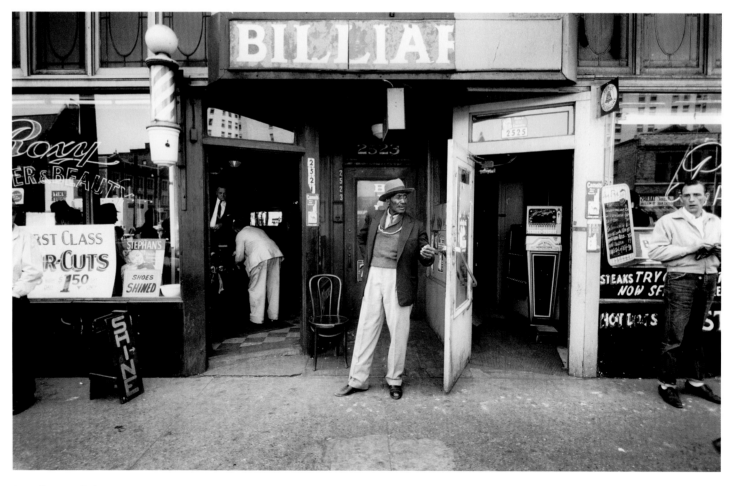

photographer J. Edward Bailey (died 1982) would publish a book of his images that focused largely on economically depressed neighborhoods in the black community.[9] Further documentation of Detroit's neighborhood streets came in 1976 when amateur photographer and Detroit art patron James P. Duffy (1923–2009) took more than three hundred photographs of mom and pop shops, scrap yards, boarded-up storefronts, and gang graffiti that he saw while driving the streets of Detroit (fig. 3).[10] His images characterize the topography of the city in the years following the 1967 riots. And by the early 1990s, the persistent state of decline in Detroit and elsewhere in America became a frequent subject for Camilo Jose Vergara (born 1944), who photographed the effects of urban decay on cities throughout the United States, which he published in *American Ruins* (New York, 1999). Vancouver-based conceptual artist Stan Douglas also traveled to the city in 1999 to create work for a series based in Detroit, as well as a video *Le Détroit*. His work was among the first to engage Detroit and its decline as a subject for contemporary art and initiate a critical investigation of the modern metropolis of the past and its failure as a utopian model in the present and future.

fig. 3. James Pearson Duffy, *Untitled*, ca. 1976, gelatin silver print, 2⁷⁄₈ x 4³⁄₈ in. (7.3 x 11.1 cm). Gift of James Pearson Duffy, 2006.96.297

This brief history is intended to draw attention to the work of numerous past photographers and demonstrate their in-depth documentation and conception of the city as subject for more than eighty years. Hardly the blank canvas that some critics and commentators have suggested, Detroit has been branded in its identity and representation through photographs that chronicle its social environment, industry, and ever-changing urban space. Looking forward to the twenty-first century, a reinvigorated photographic art practice has emerged, informed by the same interests, traditions, and history of the past, but concerned with a reevaluation of these issues and sometimes the broadening perceptions and representations of the city.

By 2000, the aging Rouge plant was rumored to be on the edge of extinction. Employment had dropped considerably, and the work force, which had numbered 60,000 at mid-century, was down to 6,000 by 1999. But in 2001, Ford CEO William Clay Ford, Jr., great-grandson of Henry Ford and an environmental advocate, announced a multimillion-dollar plan to renovate and green the plant. Detroit-based photographer Michelle Andonian (born 1958) convinced the company that documentation of the renovation process was important to continue the photographic legacy that had begun at the Rouge with the work of Sheeler in 1927. In 2003 and 2004, she embarked on a two-year project to record the plant's turnover of operations from the production of the Mustang to the F-150 truck (pages 4–5, 34–39). Photographing in the black-and-white documentary tradition, she tells the story of steel production from its origins as ore and limestone to its journey out of the blast furnace and into the foundry, where it is shaped into slabs and sheets to be rolled and stored on site (page 36, top). Eventually, the gleaming steel is sent to the stamping presses to be pounded into auto parts (page 36, bottom). Over the years, some aspects of assembly-line production had been turned over to robotics, and the Rouge was also home to what workers referred to as the "IBM line," the first computer-operated assembly area of the factory (page 5). Witnessing the last days of Mustang production, Andonian photographed several of the workers, some of whom would move from the Rouge to the Mazda plant in Flat Rock, Michigan (page 33). When it came time to photograph the new Dearborn Assembly plant, she turned to large-format color photography to capture the color and brilliance of its state-of-the-art auto manufacturing procedures (page 39). Her work remains a commemoration of the past as well as a representation of Detroit's uncertain future as the auto companies and their workers struggle to survive and adapt in the postautomotive era.

Industry has been a critical and overwhelming force in the formulation of Detroit's identity, but several artists in *Detroit Revealed* have looked to portraiture to define the character and relevance of real people, their concerns, and life in the first decade of the twenty-first century. In 2003, young Detroiters shared stories about their diverse backgrounds, realities, and desires with Chicago-based photographer Dawoud Bey (born 1953), who collaborated as an artist in residence with the Detroit Institute of Arts and teens at Chadsey High School (pages 41–43). There Bey made the video *Four Stories*, as well as portraits of students accompanied by their quotes. Many of the teens he encountered were first-generation Americans, such as Gheorghina, a young girl of Eastern European descent, who loves to sing. Another, Sukana, saw her life as directed by strong ties to her culture. In Bey's video she remarked, "One thing I like about being an Arab-Muslim-American young lady is that—no matter what—my culture is always going to be there. There's a lot that I may dislike about it (that's complicated) but for some reason you can't really just move away from it." Yahmáney, a native Detroiter and African American, discovered that hard work might earn him good grades, but he also understood the stigma of being a young black male from a big urban city. He knew the varied paths his life might take, and that other people's perceptions and assumptions of who and what he could be might disempower him. In the end, the strength of his family would bring his life into focus, as his comments in *Four Stories* emphasize: "[family] taught me how to actually become a gentleman, and I'd rather be a gentleman than some dude on the corner doing nothing." For these teens that live in one of Detroit's most ethnically diverse neighborhoods, community, family, peer pressure, and the need to assimilate into or reject American culture factor into their process of understanding and defining their personal identity.

Discovered and settled by the French in 1701, Detroit saw its first wave of European immigrants in the early nineteenth century. Irish settled on Detroit's southwest side and were later joined by Maltese and Mexican immigrants after 1900.[11] Over the century, business development and population surged in the area, so that by 2000, more than 47,000 Latinos were in residence.[12] In 2010, Carlos Diaz (born 1951) worked with this community, known as Mexican Town, to create a series of portraits and oral histories, as well as photographs of residences that were taken throughout the neighborhoods (pages 3, 45, 48–49). Diaz took frequent walks through the area to better familiarize himself with the neighborhood and find subjects for his portrait series.

He photographed many of the homes, some meticulous in their appearance, with their lush gardens and occasional shrines filled with personal mementos, flowers, and statues of the Virgin of Guadalupe, one of Mexico's most revered patron saints (fig. 4). Diaz saw his work as an opportunity to celebrate the Mexican American heritage of Detroit and overturn stereotypes of Mexican immigrants as "alien," "illegal," and "undocumented." He set out to record individual stories and saw the faces of his subjects as roadmaps telling of their life experiences. Many have left their native Mexico to seek a better life, work, and family in Detroit. His photographs celebrate and pay homage to their individual likenesses through a series of portraits framed by *tondi*, a round format harking back to the Renaissance (pages 46–47).

Informed by their own ethnicities and personal experiences, Bey and Diaz give visibility to and tell the stories of average individuals who live out their lives in Detroit at a particular historical moment. Their work provides a commentary on the diversity of the community and extends a critical discourse for the relevancy of art in representing and defining these communities. In their use of the portrait, a traditional genre for fine art, they create both a description of the individual as well as an inscription of their social identity.[13] As complex signifiers, portraits form a genre that is also shaped by an enduring historical trajectory rooted in the traditional context of art itself. Portraits, a staple in galleries and art museums, typically take as subjects historical figures and affluent individuals. Working with a larger-than-life scale reminiscent of grand portrait paintings, Bey and Diaz give significance to ordinary people with extraordinary stories.

In these portraits, resilient Detroiters offer the experience of life in a city where human existence would otherwise seem absent or abject, as seems apparent in the many photographs of its abandoned and vacant areas. It is this dark and unbelievable side of Detroit that has attracted curiosity seekers, adventurers, and so-called ruin gazers who, armed with digital and cell-phone cameras, have descended on the city over the last decade. The imagery of many of these urban explorers dominates photo-sharing sites on the Internet. But along with these amateur photographers, serious artists have also made the pilgrimage to Detroit for a unique glimpse into the sublime, where time seems suspended and the glory of a civilization now past has taken hold of the onlooker.[14]

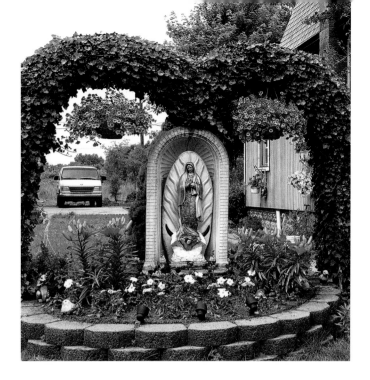

fig. 4. Carlos Diaz, *Untitled* (detail), 2010, pigment print, 20 x 26³⁄₄ in. (50.8 x 67.9 cm). From the series *Beyond Borders: Latino Immigrants and Southwest Detroit*. Museum Purchase, Albert and Peggy de Salle Charitable Trust, T2011.16.7

On numerous trips to Detroit in 2008 and 2009, New York-based photographer Andrew Moore (born 1957) traveled to the city to continue the development of a growing body of work that reflects his interests in architecture, the cycles of history, and his search for places where the convergence of past and present are strangely brought into awareness. He is one of very few photographers to have wielded a traditional, large-format, 8 x 10 camera on the streets of Detroit and in its treacherous buildings. The camera allowed him to produce images on a monumental scale with highly refined detail. He photographed at the Rouge (pages 62–63), and the resulting image, made from a digitally scanned negative, is slightly more than 5 x 6 feet. The photograph captures the interior's weathered surfaces and the patina of age with a sharpness and clarity that reveals more than what the eye may be able to see. Moore's photograph also provides a sense of the unique quality of light at the complex. Albert Kahn, the architect, had incorporated

large banks of windows and skylights into many of his industrial buildings to provide natural light for the workers in sites such as the Rouge's Rolling Hall, where they shaped metal from the foundry into slabs and sheets. The site is now vacant, and in viewing Moore's photograph, one gets the sense of the Rouge as an awe-inspiring architectural space with a history and important function that has now slipped into the past.

In addition to his work at factories and abandoned industrial sites, Moore frequently worked in Detroit neighborhoods. He photographed The Aurora (page 8), a once upscale apartment building in Brush Park. The neighborhood, developed in the 1850s by Edmund Brush, was home to Victorian mansions. Many of its historic houses have fallen into disrepair; some have undergone renovation, but subsequent demolition in nearby areas has created vacant properties surrounding the apartment. In another photograph, Moore found a makeshift domicile that belonged to a homeless man living in the warehouse at The Detroit Dry Dock Engine Works Company Complex (fig. 5, page 61).[15] Like other abandoned buildings in the city, the structures have become a refuge for the homeless, who, in Detroit, form the third largest such population in the nation.[16] Moore's work considers the quality of existence and the cycles of civilization throughout history, and his photographs signal the decline of modernism, which promised a better life and society.[17]

fig. 5. Andrew Moore, *Shelter, Engine Works, Detroit Dry Dock Company, Rivertown Neighborhood* (detail), 2009, pigment print, 57 x 45³⁄₈ in. (144 x 115 cm). Museum Purchase, Albert and Peggy de Salle Charitable Trust, 2010.33

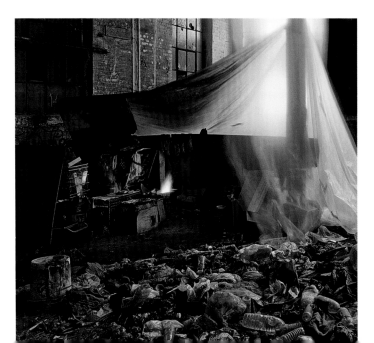

Artists like Scott Hocking (born 1975) were inspired to repurpose Detroit's abandoned buildings for the sake of his site-specific installation work. Interested in the history of Detroit from ancient times through the present, the continuum of time, and the reclamation of nature over manmade landscape, Hocking has, since 2000, foraged throughout Detroit's industrial landscape for found objects to be used in his mixed-media installations. He expanded his artistic practice to include photography, and frequently works in leveled neighborhoods and abandoned industrial areas (pages 51–57). He also uses the medium to document his site-specific installations throughout the city. In a work from 2008, he constructed a sculpture based on the form and shape of an ancient pyramid-like temple, appropriately entitled *Ziggurat* (pages 56–57). The project began in December 2007 and took more than eight months to complete. It involved the placement of more than 6,000 wooden floor blocks found on site in the abandoned Fisher Body Plant. The photograph is a lasting document of work that would disappear in September 2008, after a clean up and closing of the building by the Environmental Protection Agency.

Hocking took on other ambitious installation projects, including *Garden of the Gods* (pages 54–55), which he built and completed on the collapsed roof of the Packard Plant in 2009. His view includes an adjacent cemetery, alluding to the transience of humanity, and the expansive Detroit horizon. For the artist, this site, with its concrete columns, was reminiscent of the Roman Forum and Bernini's Piazza San Pietro. The installation represented the twelve gods of the classical Greek Pantheon, and Hocking used columns as pedestals for twelve discarded wooden television consoles he found in the plant (fig. 6).[18] Hocking photographed the site during the changing seasons and here, as seen in many of his photographs, he has captured the otherworldly winter light and strange stillness of time that defines his perception and experience of twenty-first-century Detroit.

As the sites of continual transition, cities can experience a range of events that determine their condition—expansion and decline, development, redevelopment and overdevelopment—and they suffer and thrive during periods of political and social upheaval and renewal. As the decade closed and leadership in the U.S.

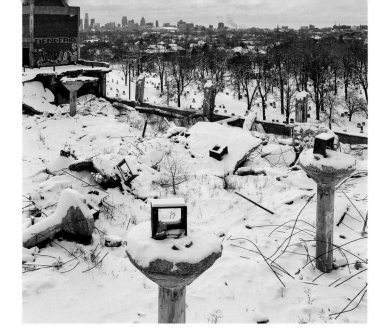

fig. 6. Scott Hocking, *Garden of the Gods, South, Winter* (detail), 2009 (printed in 2010), pigment print, 33 x 49½ in. (83.8 x 125.7 cm). From the series *Garden of the Gods*, 2009–10. Gift of the artist, Scott Hocking and Susanne Hilberry Gallery, 2010.63

government transitioned, photographer Alec Soth (born 1969) was moved to "make some little mark" on the state of America and its apparent fallout in a "country exhausted by its catastrophic leadership." While traveling across America on various assignments, he created the series *The Last Days of W.*, citing the end of George W. Bush's eight-year presidency as inspiration for the work. Soth made several photographs while in Detroit and just north of city in the financially troubled Highland Park, a former boomtown and home to the Ford Model T production before operations moved to the Rouge in 1927. While there he discovered an abandoned housing project begun just prior to the economic downturn that erupted in Bush's last year as president (page 65). According to Soth, his photographs from *The Last Days of W.* represented "this time in America, and we all experience it, and it was like this is what we are all dealing with."[19]

Like the other photographers in *Detroit Revealed*, Soth uses photography and the subject of Detroit to define the American state of mind and offer a critical perspective of society in the first decade of the twenty-first century. Interestingly, Soth's photographs from *The Last Days of W.* began with another assignment on America's influence and status in the world while he traveled in the United States with Europeans. Admittedly, he began to see "the country through their eyes."[20] The relevance of outsiders' perceptions of America continues to influence the nature and reception of the city in the public eye, as seen in *Detroit Revealed* in recent work by two European photographers, Ari Marcopoulos (born 1957) and Corine Vermeulen (born 1977), both based in the United States.

When Marcopoulos created photographs and a video entitled *Detroit*, he tapped into the unique underground world of Detroit music that has been alive in the city for many decades. Through friend and fellow artist Andonian, the photographer discovered Hunter and Shane Muldoon in the southwest Detroit home of their parents. The chance meeting resulted in a quick performance that Marcopoulos captured on video. The two young brothers were recording artists and members of the punk-rock garage band The Muldoons, which they formed with their dad Brian in about 2004. Marcopoulos gives insight into the intimate world and minds of the two young musicians in a series of informal photographs of Hunter and Shane in their home, where guitars and posters of rock musicians grace the colorful walls of their small bedroom (page 59). He included these still photographs in the book *Detroit 2009*, in which the Muldoons appear in the center spreads surrounded by other photographs from Detroit's graffiti-strewn freeways, buildings, and abandoned factories. Scratching beneath the surface of the city's cold and often forlorn exterior, Marcopoulos's work is evidence of the vital life and creativity that continues to emanate from within the city. Realizing that so much may lie beneath the surface, Marcopoulos may be suggesting to those passing through or looking upon the city to "Sit.Stay.Love.," as seen on a billboard he photographed (fig. 7).

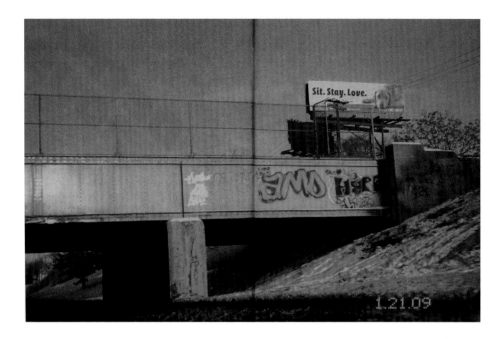

fig 7. Ari Marcopoulos, *Untitled*, 2009, offset printing on green newsprint paper, 10 1/2 x 12¹³/₁₆ in. (26.6 x 32.5 cm). Spread from *Detroit 2009*. Gift of anonymous donor, T2011.83

An artist's physical immersion into the culture of a city, however brief or long term, will result in new perspectives and a reevaluation of that city's identity and its complexity as a society. Corine Vermeulen, who has lived in Detroit since 2006, uses the medium to uncover and document the people and places that characterize and define new urban lifestyles and to comment on the continuing challenges of those living in Detroit's postindustrial age. She has photographed her young neighbors like William (page 67), a multiethnic Detroiter who represents the future generation of city dwellers. Vermeulen is also likely to photograph strangers willing to share their personal stories and give insight into their lives. Emily (page 70), a Detroiter who has persevered after suffering a gunshot attack that left her physically impaired, shows resilience and confidence in her 2010 portrait. Vermeulen frequently looks to the ordinary and everyday cycle of life to define the Detroit experience today. While visiting the Catherine Ferguson Academy, a school for pregnant and parenting teens in Detroit, Vermeulen made a portrait of Sweater, a sheep who is part of the school's community farm (page 7). Students at the academy learn the basics of farming and sell the fruits and vegetables they grow at the local farmer's market.

Like the other photographers in *Detroit Revealed*, Vermeulen is conscious of history and the ability of a photograph to uncover layers of meaning. An image taken at the 2010 Detroit Electronic Music Festival (DEMF) shows a group of fans in full costume posing for the camera (pages 68–69). The annual festival draws thousands of people to the city where electronic music emerged in the 1980s. The DEMF takes place on Detroit's riverfront at the site where seventeenth-century Frenchman Antoine Cadillac landed; across the river is Windsor, Ontario. The skyline would have been a familiar and welcome site to nineteenth-century African Americans who found their way to Detroit and freedom in Canada via the Underground Railroad. But the subjects of her photograph are completely unaware that they are posing with a statue that commemorates this history. As Detroit changes and new generations of individuals help to reinvent it, the photograph poses many questions and addresses the future of Detroit, its past, and the difficulty with isolating and defining a singular identity of present-day Detroit.

Unification of Detroit's fractured community and the beginning of a productive dialogue for all its people is another challenge, but one that may find resolve in new forms of social activism. Vermeulen's panoramic image of a tent city (pages 72–73) might be interpreted as a place of urban misfortune—a makeshift shelter for victims of disaster or the homeless. But the photograph actually commemorates the 2010 arrival of the U.S. Social Forum, whose participants encamped on property along Detroit's main thoroughfare, Woodward Avenue.[21] Two uniformed individuals stand guard in the foreground. They are members of Detroit's V.I.P.E.R.S. Academy, courtesy of Threat Management, an organization that began in the mid-1990s and specializes in nonviolent security enforcement. The group, whose founder was intent on empowering individuals to protect themselves from urban violence, represents the strength and entrepreneurial spirit of Detroiters who believe they can change the quality of life for themselves and others in the city.[22]

Vermeulen has stated, "Detroit represents a unique and great vehicle for change, where old structures are no longer in place and the possibilities for something different to happen are endless." In the imagery of Vermeulen and the other photographers in this exhibition, we see a reevaluation of the city's past, present, and uncertain future. Through their engaged observations and enlightened perceptions, the photographers of *Detroit Revealed* have just begun to change the representations of Detroit by attempting to broaden what has been a once narrow and limiting image of the city.

NOTES

1. For a brief discussion of government officials who used photography to document and promote a new image of Paris, restore the country's pride in its cultural patrimony, and bolster the monumental greatness of Napoleon II's Second Empire, see *A New History of Photography*, ed. Michel Frizot (Cologne, 1998), 198–99.

2. James Cooper and Noreen O'Leary, "Detroit City Limits: A New Generation of Agencies is Striving to Redefine the Auto Industry," *Adweek*, http://www.adweek.com/news/advertising-branding/detroit-city-limits-130623?page=2. Accessed 5/4/11. The authors note, "Even in its demise, a new artistic photographic genre, 'ruin porn,' draws its inspiration from Detroit's decay."

3. Nancy Barr, "Truth, Memory and the American Working-Class City: Robert Frank in Detroit and at the Rouge," *Bulletin of the Detroit Institute of Arts* 76, nos. 1–2 (2002): 62–74.

4. Terry Smith, "Henry Ford and Charles Sheeler: Monopoly and Modernism," in *Making the Modern* (Chicago, 1993), 93–135.

5. Robert Frank, *The Americans* (New York, 1959). In 1958, Frank published the first French edition, *Les Américains*.

6. Bill Rauhauser became a dedicated proponent of fine art photography in Detroit, which prior to 1960 had largely fallen under the domain of amateur camera clubs and salons throughout the city. Rauhauser established the first commercial photography gallery in Detroit and advised the Detroit Institute of Arts on acquisitions and the organization of exhibitions from the early 1960s through the 1990s. Originally trained as an engineer, he quit the profession to become a full-time photography teacher at the Society of Arts and Crafts (now the College for Creative Studies) in 1970. He was instrumental in shaping formal instruction and establishing a methodology for the black-and-white documentary tradition at the college and in the community.

7. John J. Bukowczyk and Douglas Aikenhead, *Detroit Images: Photographs of the Renaissance City* (Detroit, 1989). Work by several of Rauhauser's students was published in this book, which included photographs by fourteen prominent Detroit-based photographers.

8. Thomas Sugrue, *The Origins of Urban Crisis: Race and Inequality in Postwar Detroit* (Princeton, N.J., 1996), 259. As Sugrue notes, the riot began on a hot July evening after arrests at an illegal after-hours bar in a black neighborhood on Detroit's Twelfth Street.

9. In 1969, Bailey's photographs were on view at the Detroit Institute of Arts in the exhibition *The City Within: Photographs by J. Edward Bailey III*.

10. See *Up from the Streets: Detroit Art from the Duffy Warehouse Collection*, ed. Jeffrey Abt (Detroit, 2002).

11. "Corktown Historic District," from the National Park Service, http://www.nps.gov/history/NR/travel/detroit/d19.htm. Accessed 5/5/11.

12. Corey Williams, "New Latino Wave Helps Revitalize Detroit," *USA Today*, February 2, 2008, http://www.usatoday.com/news/nation/2008-02-28-2962316916_x.htm=. Accessed 5/9/11.

13. John Tagg, *The Burden of Representation* (London, 1988), 37. Tagg notes that the portrait has this dual purpose.

14. The most successful of these photographers have published books, including Andrew Moore's *Detroit Disassembled* (Akron, 2010), Dan Austin and Sean Doer's *Lost Detroit* (Charleston, 2010), and Yves Marchand and Romain Meffre's *The Ruins of Detroit* (Göttingen, 2010).

15. Thomas A. Klug, *Historic American Engineering Record: Dry Dock Engine Works, HAER no. MI-330* (2002), 1. One of the first industrial complexes to include steel frame construction, its six buildings and dry dock were constructed in the late 1890s and completed in 1919.

16. *National Survey of Programs and Services for Homeless Families, Michigan* (fall 2010), 1–2, http://www.icphusa.org/PDF/reports/ICPH_Michigan_Brief.pdf. Accessed 5/9/11.

17. Lecture with Andrew Moore, Oakland Community College, Oakland County, Michigan, March 2010.

18. Scott Hocking, *Scott Hocking*, http://scotthocking.com/. Accessed 5/9/11.

19. "Interview with Alec Soth," July 21, 2009, http://toomuchchocolate.org/?p=1067. Accessed 5/9/11.

20. "Interview with Alec Soth," July 21, 2009, http://toomuchchocolate.org/?p=1067. Accessed 5/9/11. Soth notes he was traveling across America with a British journalist and two French filmmakers.

21. "What is the U.S. Social Forum?," http://www.ussf2010.org/about. Accessed 5/19/11. The U.S. Social Forum is a social movement brought to cities in the United States, where people can convene to develop their own solutions to economic problems in their communities.

22. "Threat Management: About Us," http://www.threatmanagementcenters.com/about.html. Accessed 5/19/11.

John Gallagher

# DETROIT TODAY

Let's start with a memory. People tend to scoff today at the civic pride evidenced in the 1960s-era documentary *City on the Move*, produced as part of Detroit's bid (unsuccessful) to host the 1968 Summer Olympic Games. The film highlighted the city's many assets—its humming auto factories, its bustling expressways—and it included a clip of President John F. Kennedy endorsing the bid. As an example of hubris before a fall, it's hard to beat: the city was seeping jobs and population even then, and the film (still available on the Web) boasted of Detroit's model race relations not long before race riots ripped the city asunder and sent thousands of families fleeing to the suburbs. Yet viewing the film with hindsight today, the most remarkable thing about *City on the Move* is not its outdated optimism but rather how much of what it portrayed remains valid. Case in point: the filmmakers touted the city's great center of learning Wayne State University, along with Detroit's magnificent cultural institutions and its world-class hospitals; those anchor institutions are still in business today, and in fact operate bigger and are busier than ever. The Tigers and Red Wings still contend, the riverfront is more accessible, and the city's residents remain a passionate, deeply committed bunch.

This is not to say that all is fine in Detroit; even a fleeting glance blows away any such notion. Detroiters may cringe at the media's portrayal of their city as an urban dystopia, but the image of Rust Belt failure is, of course, deserved. Detroit bleeds from a thousand wounds, and no happy talk will make that any less obvious or any less painful.

The point of a more positive beginning to this essay is to state the obvious: that Detroit is many cities today, a place of thriving neighborhoods yet abysmal abandonment; a city of highly educated professionals that is filled with illiterate drop-outs; a city of soaring achievement in medicine, the arts, and industry, yet a city that presents the most dispiriting vistas in urban America. No one vision or book or film or speech or exhibit or political agenda can capture the whole of Detroit today.

This is not quite the same as saying that any and all portrayals of Detroit are equally valid, merely that Detroit today stands as among the most complex urban environments in the world, absolutely unique in many ways. To truly understand this city one needs to look beyond not only the boosterism of *City on the Move* but also the "ruin porn" of so many current portrayals. Even after nearly 25 years covering this city as a journalist, I still learn new things about Detroit every day.

Photographers flock to this city today, along with journalists, academics, urban planners, sociologists—indeed anyone with an interest in the globe's great urban story of the early twenty-first century: What will happen to Detroit? True, many of the visitors come just to feast on the carcass of a once-great city, photographing wreckage and tut-tutting over the city's ills. But many people come to observe a new city being born. Listen to these visitors and you'll hear them say things like "Detroit is the new Berlin," meaning a city that will rise from the ashes (it's been done before, here) and recreate itself as a vibrant metropolis. Some believe Detroit will teach the world how a city can grow greener and more environmentally sustainable by producing much of its own food and energy, to a degree unknown around the world and that other cities will emulate. Others anticipate that Detroit will create new governance models to replace what is basically

a nineteenth-century structure for governing large urban areas. There's no certainty Detroit will implement any of this new thinking. Detroit's half-century fall from grace may continue, adding new chapters to that dreary saga of riots and redlining, white flight and suburban sprawl, shuttered factories, broken dreams, and wasted lives. But the opportunity to grow into a smaller but better city is real. Detroit has a chance, as William Faulkner said of mankind, to not only endure, but prevail.

BEGIN WITH the assets. Even in its distressed state, Detroit today remains home to about 700,000 residents, ranking it among the top twenty U.S. cities in population. General Motors, one of the world's major manufacturers, calls the city home, while Ford and Chrysler are based nearby. Detroit's location at the most strategic spot on the Great Lakes offers the same critical advantages that the French entrepreneurs saw in 1701. The city boasts world-class medical facilities, a major research institution in Wayne State University, historic architecture, excellent roads and airport facilities, and a populace that remains passionate about its sports, music, and hometown.

But this tallying of assets does little to soften the drum roll of dreary statistics. Detroit has lost 60% of it population since its 1950s peak (1.8 million to 713,777 at the 2010 Census). The city's public schools rate at or near the bottom of all the nation's urban school districts. The official unemployment rate hovers around 25%, but the unofficial estimates, once we include discouraged workers who have stopped trying, run to around 50%. Poverty remains among the worst in the nation. Much of the city's former population has picked up and moved to the suburbs. Today, only 14% of the metropolitan region's jobs are found in Detroit itself, and the percentage is still declining. Surveyors have tallied a staggering 125,000 vacant residential parcels in the city—about one-third of all housing parcels. An astonishing 40 square miles of the 139-square-mile city area are now believed to be vacant—a swath of urban prairie into which the entire city of Buffalo, NY, could be dropped.

Statistics get us only so far. To understand Detroit today, its uniqueness and its special challenges, it helps first to visit a city like Chicago or Philadelphia. Go to the most distressed neighborhoods in those cities, the most abandoned, poverty-stricken, drug-scarred districts, and we still view solid rows of brownstone buildings lining block after block. Population loss notwithstanding, those other cities still look like our image of cities—densely developed urban cityscapes unfurling mile after mile to the suburban fringe. In contrast, the vacancy of Detroit—those ghost streets with just one or two houses left, those expanses of what Detroiters long since have taken to calling urban prairie—remains Detroit's most striking characteristic. Other cities have lost population, many nearly as much as Detroit in percentage terms, but Cleveland, Pittsburgh, Buffalo, and others that have lost half of their peak populations don't convey the same look of emptiness and abandonment. In Detroit, trees and overgrowth reclaim the vacant lots; wildflowers bloom amid the rubble; grass and weeds stand tall and lush in July and August. Parts of Detroit appear closer to rural Alabama than bustling midtown Manhattan, yet it's Urban America here, too, with a population density nearly twice that of sprawling Sunbelt cities like Dallas and Houston and Phoenix.

That all this can be true goes beyond complexity into the realm of mystery. Mere facts won't get us to a new understanding of Detroit. As Abraham Lincoln said in other perilous times, as our case is new, so we must think anew, and act anew.

IT MAY HELP to remember that Detroit's story neatly falls into roughly hundred-year spans. The colonial period kicked off in 1701 when Cadillac stepped ashore from his canoe on the banks of the strait (*détroit* in French) and claimed this strategic outpost of the Great Lakes for France. A century of farming and fur trading, of battles with Chief Pontiac's warriors and a generation-long rule by the British, came to a symbolic end in 1805 when the wilderness outpost burned to the ground. Enter Judge Augustus Woodward and Detroit's second great century, a period in which the city blossomed into a financial center for the lumber and mining industries, relics of which can still be seen in architectural marvels like the Whitney Restaurant on Woodward Avenue and the Old Wayne County Building, both built with preautomotive lumber fortunes. This nineteenth-century Detroit thrived as a center of boat building and stove-making and railroad-car manufacturing and, almost incredibly, tobacco processing. This era, too, came to an abrupt end, not by a conflagration, but by the fiery emergence of a new industry that soon swept all before it.

Detroit's Auto Century lasted, one might say, until 2009, when GM and Chrysler filed for bankruptcy and even the most upbeat had to admit that the auto companies would never again dominate as they once did. But during that automotive era Detroit flourished as few cities ever had. With factories swelling with production, Detroit enjoyed a tidal inflow of workers from all over the world, and the city burst its boundaries, annexing huge swaths of nearby communities to reach its current borders in the 1920s. The tiny village of Highland Park grew from 400 residents in 1900 to 4,000 in 1910, and then to 40,000 in 1920. Detroit ranked as the nation's thirteenth largest city in 1900 and its fourth largest a mere twenty years later. The city's industrial powerhouses achieved prodigious feats of output, leading America to victory in World War II. Before the war, the entire nation produced no more than a few dozen battle tanks a year for the U.S. Army; once Detroit retooled for the war effort, a single factory here turned out 700 tanks a month. At its peak, Ford's Willow Run bomber plant produced 650 B-24s every thirty days by 1944. In the great postwar boom, when America was the only nation left standing, the contentious union–management struggles in Detroit were mostly about dividing up the spoils of near-monopoly reach. It couldn't last, of course. Other nations would rebuild, learn to compete. Detroit, sadly, ignored the competition as long as it could, until long after it was time to do something.

This long, slow postwar period of industrial slippage coincided with the great out-migration from our cities to nearby villages and towns. Suburbanization resulted from the collective choice of millions of Americans to create a lower-density urban form dependent on the private automobile. Certainly the automotive companies lobbying for new suburban roads played a part; so did federal and state subsidies for suburban growth; and so did consumer choice, as people willingly traded city streets and public transportation for big backyards and attached garages. Detroit is hardly alone is suffering big losses to the suburbs, but no city emptied out more than Detroit, as today's landscapes in the city bear witness. The loss of the city's manufacturing base left huge gaps in the city's geography. So, too, did the loss of population, as jobs went elsewhere and workers found they could afford homes in the new, less crowded suburbs to the north and west.

A city that prided itself on offering the nation's highest level of home ownership to blue-collar workers now found that those simple wood-frame bungalows didn't hold up well to abandonment and vandalism. As the city demolished thousands of empty houses to eradicate blight, the cityscape we see today, that strange mix of vibrant neighborhoods like Indian Village and mile upon mile of rural-like vacancy, began to emerge. Other cities lost industry, too, but often their lost industries occupied smaller footprints than Detroit's giant factories, and their solid brick tenement housing for workers held up better in the postwar years than Detroit's bungalows. And so we see the city as it exists today—a city suffering so much vacancy that it stands as the international symbol of urban ills.

Yet that vacancy and abandonment, viewed for so long as a calamity and a shame, now creates Detroit's opportunity for greatness. Not everyone sees it, and many believe that any sign of hope is just another mirage. Nonetheless, new urban thinkers of all stripes are heading to Detroit today because of that perceived opportunity. Detroit, the nation's most abandoned big city, stands ready to serve as the world's biggest laboratory for trying out new urban ideas.

DETROIT REMAINS POISED at its pivot point. The automotive bankruptcies of 2009, the results of the 2010 Census (so much worse than anyone anticipated), the election of Mayor Dave Bing and his call to reinvent the city to account for the realities of a shrinking city—all these factors and more have flipped a switch in the city's collective psyche, so that everyone now looks ahead to a new future and no longer to a misty, golden-hued past. Much of the new thinking revolves around land use and the attempts to repurpose those miles and miles of vacant urban prairie. The simplest intervention involves the city taking the land and holding it—land banking—for some possible future use. This the city does already; indeed, Detroit has been land banking for decades, so that now about half the city's empty spaces are owned by the city itself (or county or state) through the tax-foreclosure process. Some of the rest is held by speculators who prey on the city's distress by buying up cheap parcels in hopes of flipping them for a big score. Land banking is mostly a passive activity, and in the absence of any market demand it does little to help Detroit, or to reimagine what a new twenty-first-century city might look like.

The next level up in dealing with vacant land is the repurposing of smaller parcels in any number of creative ways. Community gardens dot the Detroit landscape. Hundreds of these smaller urban farm plots (often no more than a tenth of an acre in size) attract neighbors who grow vegetables and give away the produce to food banks or churches or, really, anyone who comes by to pick something. Public art projects fill up a little more of the vacancy, with artist Tyree Guyton's Heidelberg Project the most famous. Guyton grew up on Detroit's east side and, reacting to the slow rot setting in, began to festoon houses and lamp posts on Heidelberg Street with stuffed bears and shoes and upended shopping carts and many other found objects, all the while painting his trademark polka dots on pavement and houses alike. Initially controversial (so much so that city officials bulldozed his work twice in the early years), Guyton's creation is now a tourist draw. Pocket parks, pop-up farmer's markets, even dirt-track motocross courses fill up Detroit's vacant spaces—to a point. Add them all up and the city still faces the task of finding new uses for dozens of square miles of urban landscape on which no buildings sit, and for which there is no discernable market use or demand.

So now we come to the turning point. Having lost the residents and industry that used to occupy that land, and having failed to fill it up with new development or community gardens and other small-scale interventions, can we now imagine a new sort of Detroit? People who favor this approach believe Detroit can grow into the greenest, most environmentally sustainable city in the world. They foresee commercial farms flourishing in Detroit's empty spaces, creating not only food for the needy but jobs and a tax base tied to the processing, distribution, and marketing of food, including even agritourism in the form of winery tours. (Detroit is already surrounded by wineries elsewhere in Michigan and in Ontario, so why not the city?) Visionaries foresee restoring some of Detroit's natural landscape that the French found here by "daylighting" streams long-ago buried under concrete. Detroiters may one day heat and cool their homes and businesses with energy produced from wind and solar panel farms within the city's limits, or from geothermal wells sunk deep to tap the earth's natural heating and cooling properties. All these activities could build a new industry based on feeding and powering a city, and new governing models could emerge for transferring power from the dysfunctional municipal city government of today to smaller, more nimble neighborhood-based bodies. All these things are possible because Detroit is a smaller city today. The problem has become the promise. Detroit can be a great city again not only in spite of being smaller, but because of it.

THE PEOPLE WHO inhabit the Detroit of today defy easy characterization. The city is largely African American but holds significant populations of whites and Latinos, immigrants from many nations of the Middle East, and others. Detroit ranks among the nation's poorest cities yet enjoys pockets of elegance and districts of thriving cosmopolitanism. Any portrayal of Detroiters today captures, at best, a sampling. Photographs in this book provide a glimpse at a few dozen of the faces of Detroit. Study them, and you'll see neither the hard-core, street-savvy miens of modern Los Angeles and New York or the softer, unharried lines betokening a rural life. You cannot pigeonhole these faces as people of the streets or people of the farm. They are the people of Detroit. That is all and that is sufficient. These faces show the burden of work—and work is what Detroit knows most of all—but they also show that mysterious something that, for want of a better way to put it, we can call hope in the future. In the midst of carrying their burdens, Detroiters today are people who—illogically and perhaps impossibly, yet unquestionably—remain ready to believe.

Cities have always occupied the best ground. From the long-ago July day when Cadillac stepped ashore from his canoe, through the hopeful years when Detroiters were bidding to host the Olympics, Detroit is a city that always made sense. With its strategic location, its great industrial wealth, and the boundless energy of its people, Detroit earned its spot of earth in a way few other cities did. In recent years, that sense of rightness about the city, and its place in the firmament, has faded. Outsiders scoff, they tear at the city's tattered garments, they take pleasure in the city's pain. The old glory has gone a' glimmering and the new Detroit waits to be born.

But that new Detroit lies here in embryo. It inherits the DNA of our past even as it pushes out and forward to something new and different, some new future yet to be defined by its own next efforts. No one knows what lies ahead, only that the journey is under way. We may yet define Detroit as a city on the move.

Carlo McCormick

# UNDREAMING:
## DETROIT AND THE NEW AMERICAN NARRATIVE

We hear that America has lost its ability to make things. As the economic reality of this has become an increasingly psychological meta-reality over the past few decades, Detroit has become the physical manifestation of what this actually means. As the embodiment of a grand past and a dystopian future, Detroit is a shorthand signifier for the pride and pathos by which we must now come to construct our national identity. For better and for worse, these very conditions are what makes the Motor City in the post-industrial age so very central to the American Experience. It is also what makes it so appealing for contemporary artists.

There are many reasons why a down-on-its-heels Detroit would be a vital host for artists, but before considering those we might try to understand how what Detroit represents as a whole is fundamental to its tremendous value as a place for artists. Essential to this is the very premise with which we began: the idea that because it has lost its industrial base America doesn't make anything anymore. Yes, we may not make cars, TVs, refrigerators, and other durable goods in nearly the numbers we once did, but those are not the products that define America. What is Made in the USA and, in fact, makes the USA is a far more precious commodity called myth.

Cobbled together from myriad cultures, denizens from the Old World seeking a new start, the United States evolved its cultural ethos by manufacturing its own story. That narrative, the American Dream—of meritocracy over aristocracy, the rewards of hard work, of rags to riches, streets paved with gold and glamour, a benign and loving god, of freedom, liberty, justice for all and the pursuit of happiness—is one we have exported more than any other commodity, a lie made true every day by simple virtue of the fact that we truly believed it. This epic fable, of course—though the main storyline and most prominent leitmotif of all our fictions—is hardly the only kind of account we use to distill experience. Hollywood, the great dream factory that in many ways dominates the global imagination, may continue to peddle happy endings, but for all the guilty pleasures of escapism we've developed a taste for the gritty and grim along with an appetite for vérité vernaculars and documentary forms in which the construction of truth seems not to demand so high a suspension of reality. It is to these latter impulses that photography emerged as one of the most compelling modes of media and art in American consciousness.

Pictures—especially those that bring to them an unflinching eye and a level of compassion, empathy, and understanding that bespeaks the poetics and philosophy of a true humanism amid the mediated sarcasms and ironies of postmodernism—perhaps offer us a bit more honesty than other forms of linear storytelling. This, then, is the kind of testimony we look to in the photography of Detroit over the past decade—what lies behind the lies, the beauty less evident amid the squalor, the complex and amazing stories too often untold, a way of bearing witness that avoids the clichés of condescending sympathy, hysteric hand-wringing, easy answers, or hypocritical proclamations. Detroit is the most fertile ground on which to confront the social and political issues facing America as an empire in decline, but as such it proffers itself with a nuanced subtlety and an abidingly hopeful promise that only the best of art can conjure in ways that elude the polemics of theorists, pundits, and politicians alike. That's the kind of magic offered here, the pictures that transcend words and the transformative power of the arts.

What we see in these melancholic yet proud wish-you-were-here pictures from Detroit is a new kind of urban mythology to fit a radically reconfigured American mythos. The mission of photographing the woes of urban poverty was most powerfully set forth by the reformer Jacob Riis in his landmark publication of 1890, *How the Other Half Lives*, and to that progressive history of witness photography, which would define the agenda of so much American photography from the WPA-era documentary photographers through the social-minded street photographers, we must attribute some aspect of intentionality to the work that has been produced in Detroit at the dawn of this century. More evident in these artists, however, is the break with this tradition, created in 1955, when Robert Frank began photographing for *The Americans*, opening up the subject to an artist's gaze that was entirely unlike the sense of witness that preceded it. The eight artists collected here certainly share much of the urgency that defines the politics of urban photography, but they are just as bound to the subsequent opening up of this most human landscape to the existential dimensions, social poetics, and highly personal moods and visions that artists now can express in what was formerly strictly a documentary tableau.

*Detroit Revealed* is just a glimpse that allows us to fathom how very much there is that we do not see. This is not merely a study of the urban wasteland but a fuller measure of what grows there, the graffiti and the gardens, the art, the artifacts, and even the animals that come to be in such spaces. Here the shuttering of generations-old businesses are not statistics but faces with real lives attached, and a haunting architecture of disuse, neglect, and abandonment is far from barren but very much alive. There is an undeniable patina of nostalgia at times as we confront the end of that once-heroic industrial era, but in the death rattle of one way of life passing there is the murmur of new realities stirring, a transmogrification that promises another day. How can any of us honestly look at the end of so great a modernism directly in the eye? These artists teach us to appreciate the sublime splendor of this dramatic fall by articulating the immense hope contained within despair itself. The youth of no future may have to navigate a most uncertain present in these pictures, but their very being remains one of infinite promise. So much that is neglected and marginalized sings loud in these photographs that you can hear the beat of a town that consistently produces some of the world's greatest music, as it has for more than half a century and continues to do so no matter how bad things may get there. Like the dotage of an old soul approximating the wonder of a newborn, Detroit's history crumbles away to hybrid regenerations, greening taking over the decay, signs of rebirth along the same streets that shame us all with their body count, a desperate monument to a failed past that, if we refuse to look at and understand it, may well be the signpost toward a terminal future.

Born 1958, Detroit

Lives in Detroit

# MICHELLE
# ANDONIAN

Michelle Andonian began studies in photography at the College for Creative Studies, Detroit, and later worked as a photojournalist for *The Detroit News* and *The Washington Post*. Since the late 1990s, she has traveled the world as an editorial and documentary photographer, while maintaining her home base and studio in Detroit's Eastern Market, a bustling neighborhood and public food market.

During the last three decades, Andonian has witnessed the vast and dramatic transformation of Detroit's local culture and industries. Her interests and passion for the city have led to personal photographic work that often focuses on the changing automotive industry. In the 1980s, she documented the closing of Cadillac's Fleetwood Assembly Plant, one of the last major automotive manufacturing plants in the Detroit city limits. In 2004 she completed a year-long documentary project, *Reinvention: Rouge Photographs*, on the change-over of manufacturing operations and automobile models, as well as massive modernization and greening initiatives, at the Ford Motor Company River Rouge Plant, Dearborn, Michigan. With a 35mm Leica camera in hand, she worked in a classic, black-and-white reportage style. She was allowed rare access into assembly-line areas to photograph autoworkers and their robotic counterparts, sometimes in extreme conditions, such as the blistering heat of the foundry. Her series of more than 2,000 photographic images comprises one of the most in-depth bodies of work on what was once one of the Detroit area's—if not the world's—most celebrated and infamous automobile factories.

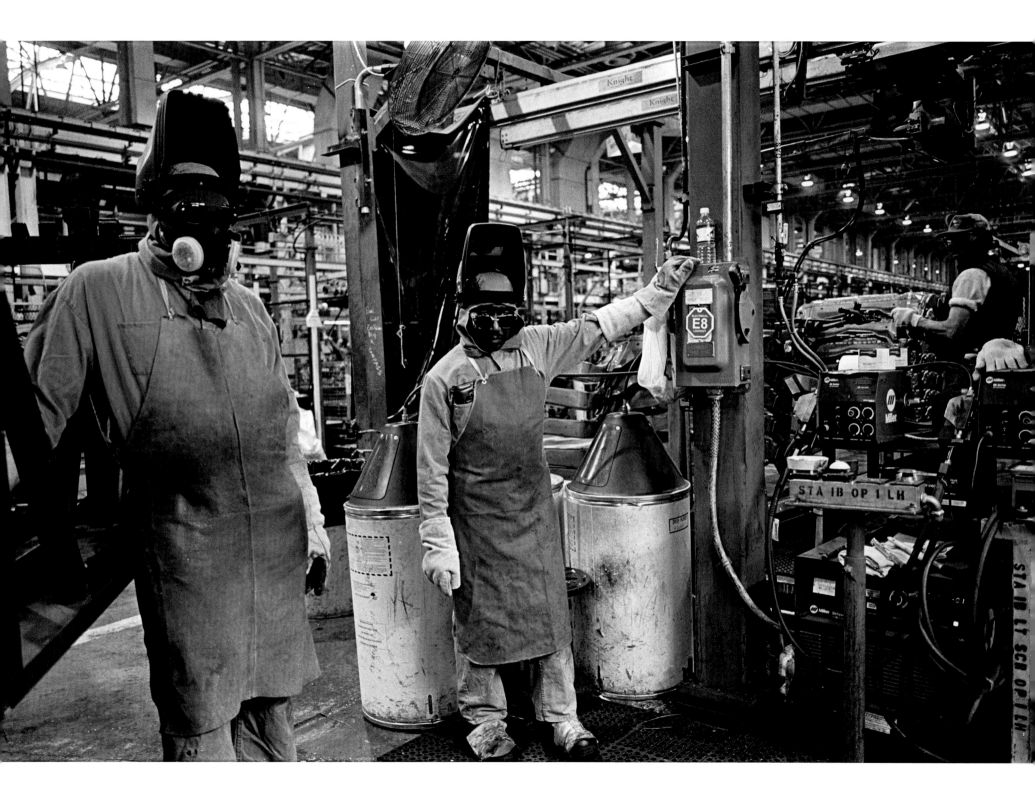

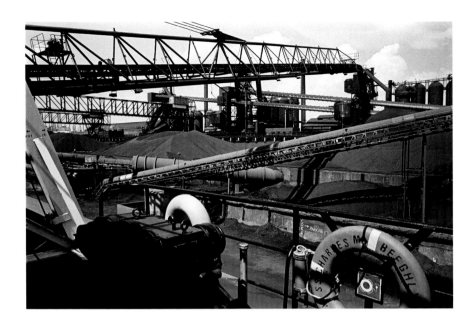

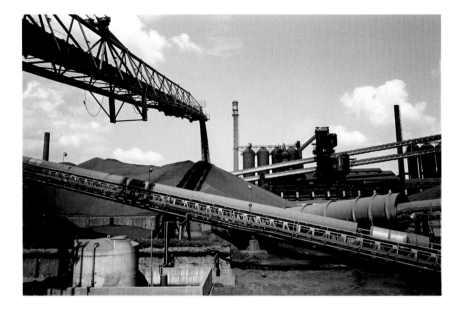

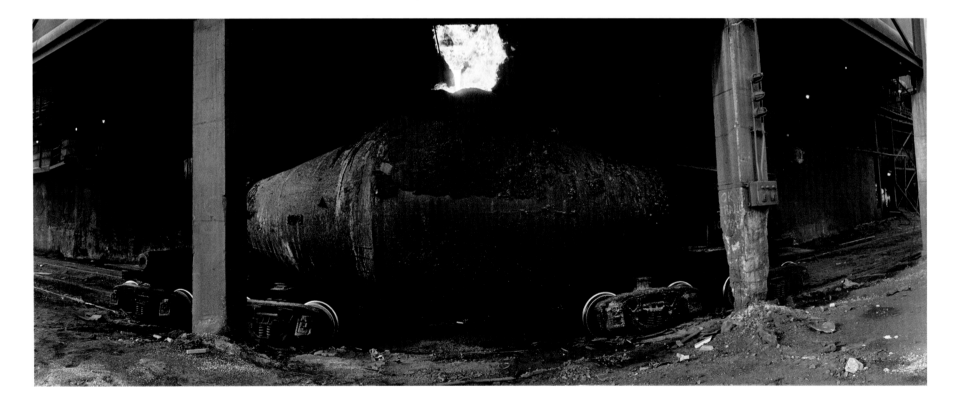

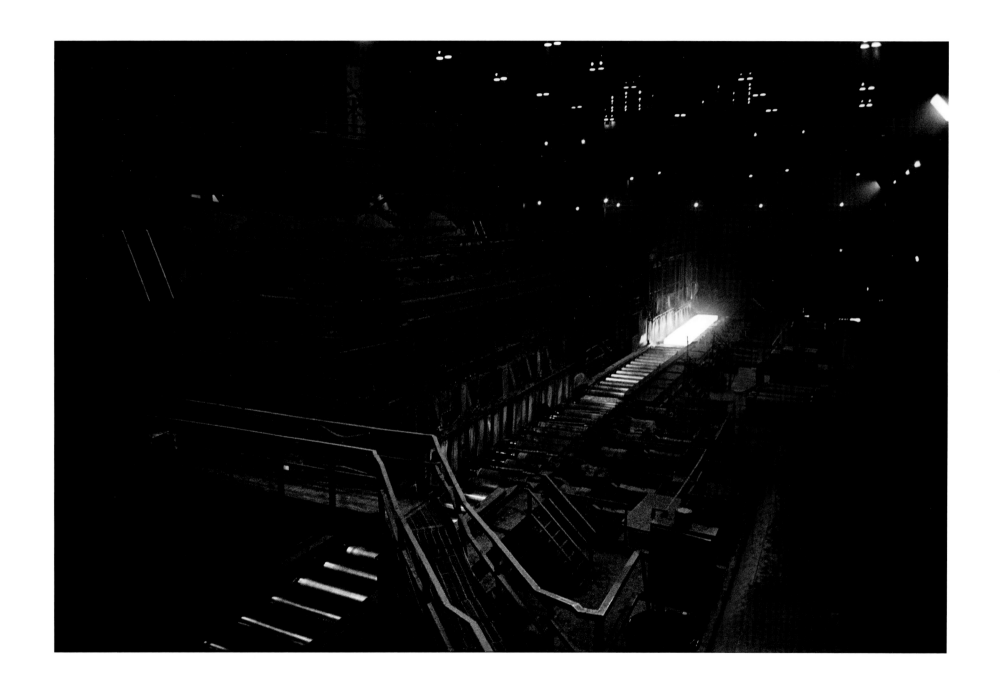

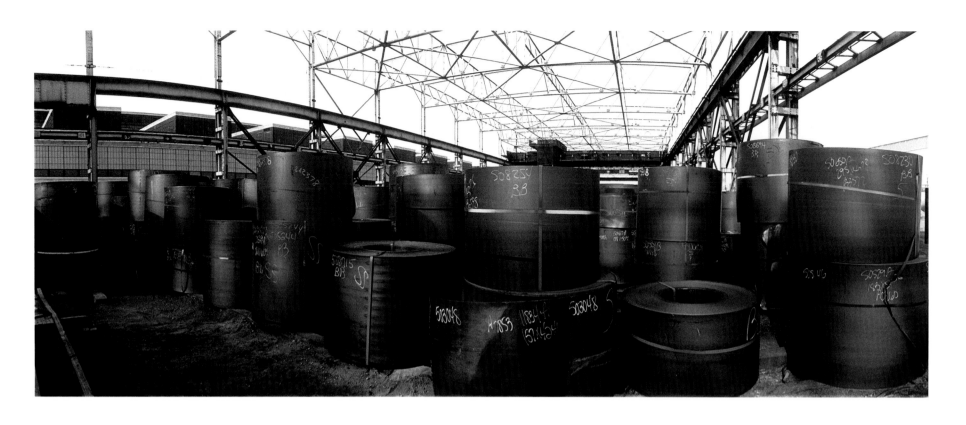

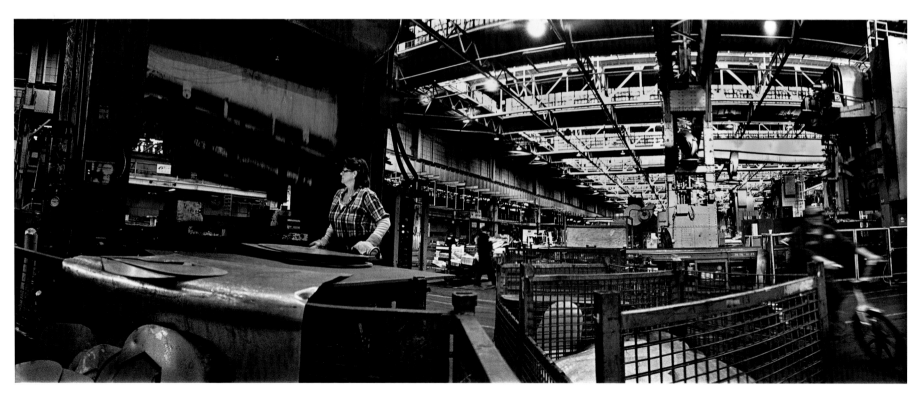

Detroit Revealed

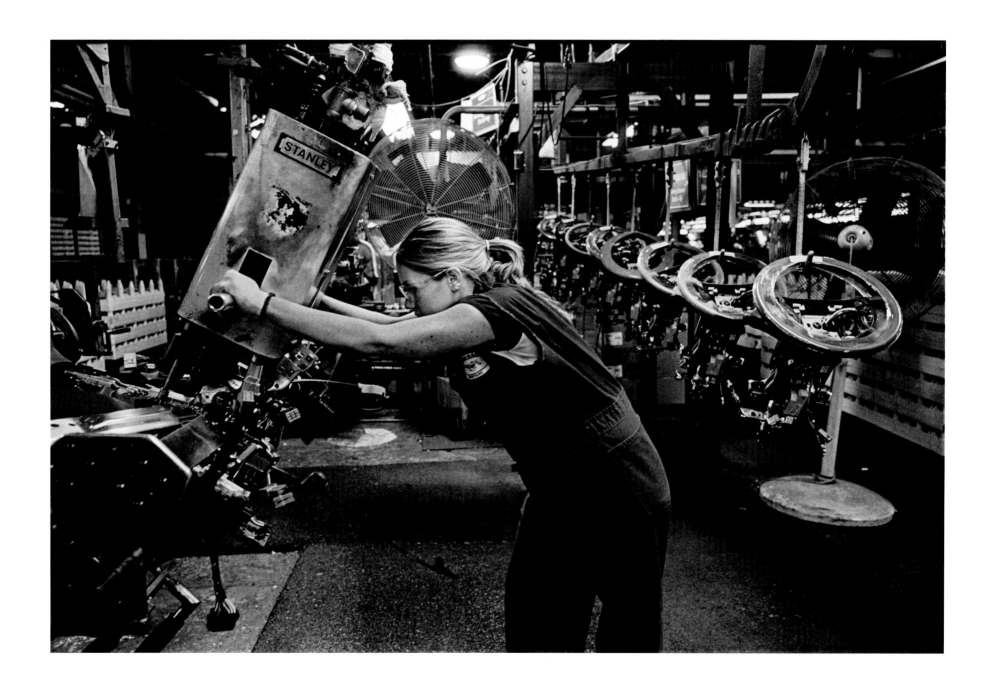

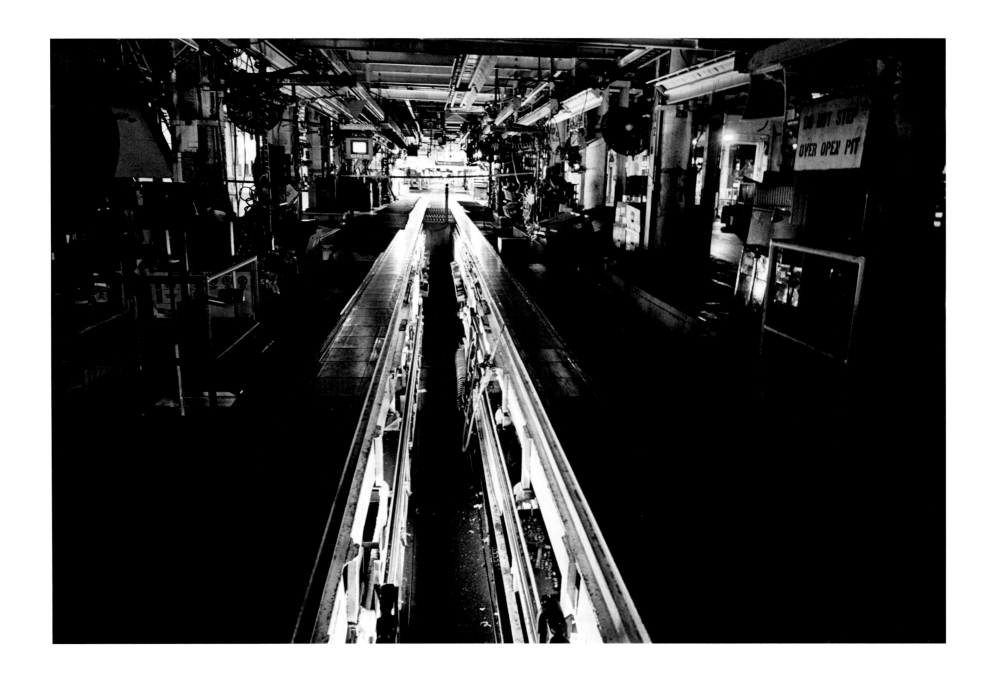

Detroit Revealed

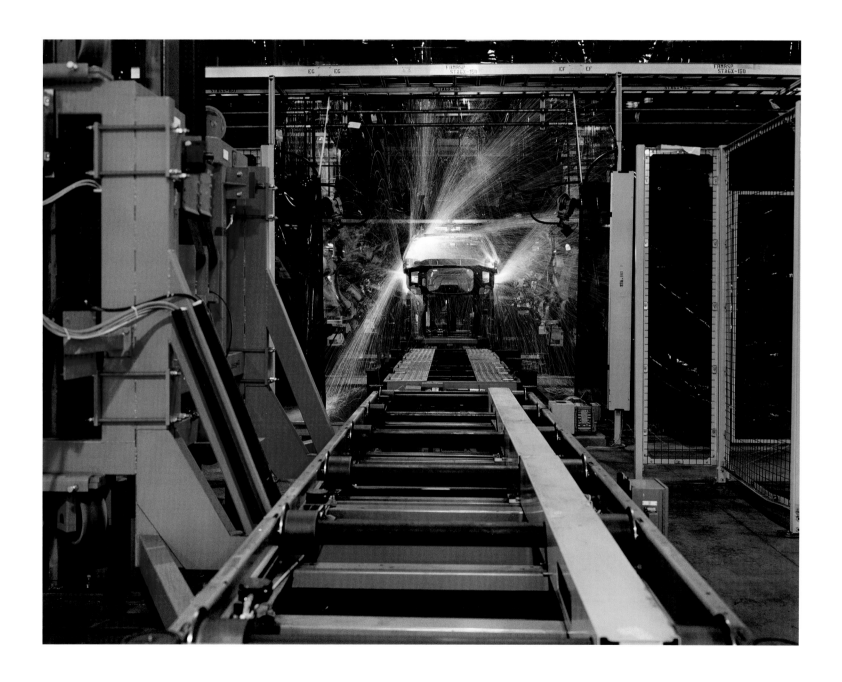

Born 1953, New York City

Lives in Chicago

# DAWOUD
# BEY

Dawoud Bey is a professor at Columbia College in Chicago. He studied photography at New York City's School of Visual Arts and later earned a BFA from Empire State College, New York, in 1990 and a MFA from Yale University in 1993. In his early work, from 1975 to 1979, he examined everyday life on the streets of New York City's African American neighborhood for the series Harlem USA.

Bey has remained dedicated to exploring and challenging social stereotypes prevalent in America. In the early 1990s, he became interested in teenagers, whom he saw as marginalized individuals often ignored and alienated from mainstream society. He began a series of portraits of teens and established residencies in collaboration with arts institutions and area high schools throughout the United States. His work had a twofold purpose: to give visibility to adolescents, their lives, and their stories, and to allow art museums to better engage and be relevant to their communities. Over the last two decades, Bey has participated in numerous residencies and exhibitions, and has created a broad and extensive body of photographic portraiture that investigates the identities, lifestyles, and diversity of teenagers across America.

In 2003 and 2004 Bey was invited to be an artist-in-residence at the Detroit Institute of Arts, where he produced a series of large-scale portraits and a video, Four Stories, that featured teens from Detroit's Chadsey High School (now closed). The subjects in his Detroit series share a common thread with other teens he has encountered throughout the years. But, unique to Detroit, Bey found one of the most ethnically diverse student populations he had ever encountered, one in which the teens, many of whom were first-generation Americans from the Middle East, Africa, Eastern Europe, and Mexico, studied and socialized alongside native Detroiters.

When I was in school I was acting like a fool. Half the time I was suspended. Then when I finally realized that I needed to change was when I got to the seventh grade. I noticed that if you act good, people treat you differently. When I was acting bad, people just treated you like a minority. They treated me like I just was nothing. I thought to myself, "Maybe if I change, people will actually start treating me differently, treating me like I got sense." Then, after, when I got into eighth grade I received my first 3.0 grade point average, then I knew if I could do that, I could do anything.

—Yahmáney

I'm one of the girls who likes to sing, I like to sing a lot, I like to work a lot. If I just sit down, and I don't do anything, it makes me bored. I like to have fun. I like to meet new people, and I like to work with children and learn about new stuff and stuff like that. I like to find new stuff every time and come to school, get my education, try to be something in life one day. I like to go to church, I like to talk to guys, they're really fun, and that's who I am.

—Gheorghina

Born 1951, Pontiac, Michigan

Lives in Milford, Michigan

# CARLOS
# DIAZ

Carlos Diaz studied photography at the College for Creative Studies, Detroit, and received a BFA in 1980. He later finished graduate work in art and photography at the University of Michigan and received an MFA in 1983. Since 1986 he has taught at the College for Creative Studies, where he is currently a professor of photography.

For more than thirty years Diaz has photographed Detroit subjects and the postindustrial landscape. More recently, he has turned his attention to the Latino community of Detroit. As a grandson of a first-generation Mexican immigrant and the son of a migrant worker, Diaz's increasing frustration with social and media perception of Latinos led him to develop a project involving Detroit's Latino community. Funded in part by a grant from the Kresge Foundation and support from the MAC group, he also collaborated with Latin Americans for Social and Economic Development, Inc., to realize his project. In 2010, Diaz completed a photo-documentary series and oral history project that celebrates and pays homage to this community through portraits of individuals and photographs of homes in the vibrant neighborhoods on Detroit's southwest side.

Diaz calls his series *Beyond Borders: Latino Immigrants and Southwest Detroit,* because he sees the U.S.–Mexico border as a symbol of the demarcation between desperation and hope. He stated, "My intent is for the faces in these portraits to read as a road map of the individual immigrants' experiences, their unique set of circumstances, and the story of their 'journey' from the border to the north. These portraits are then my attempt to personify the people of this community by removing the mask that these individuals have been forced to wear."

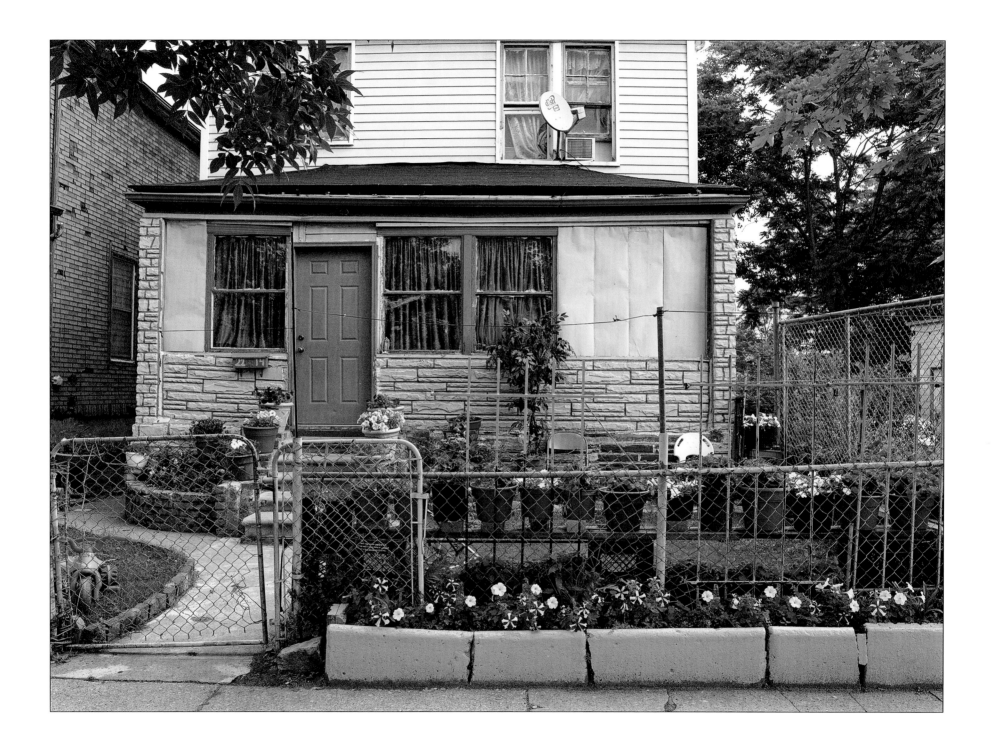

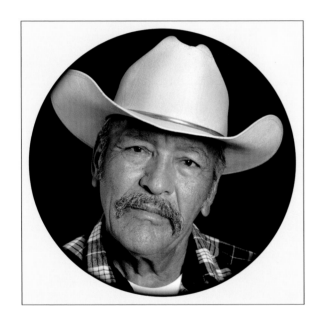 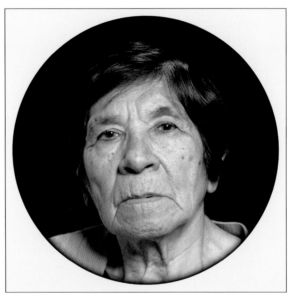 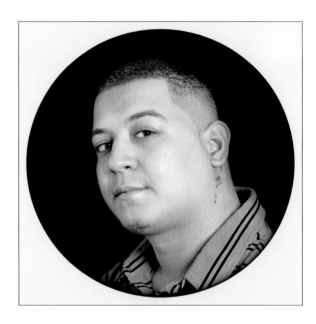

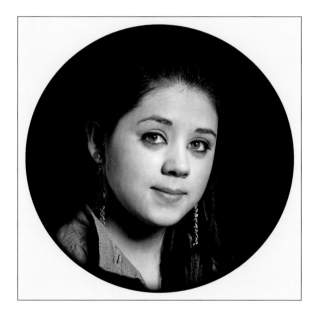 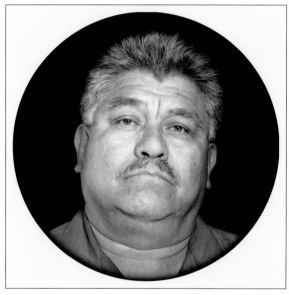 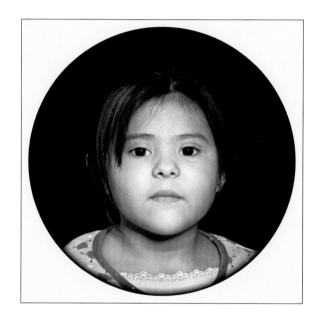

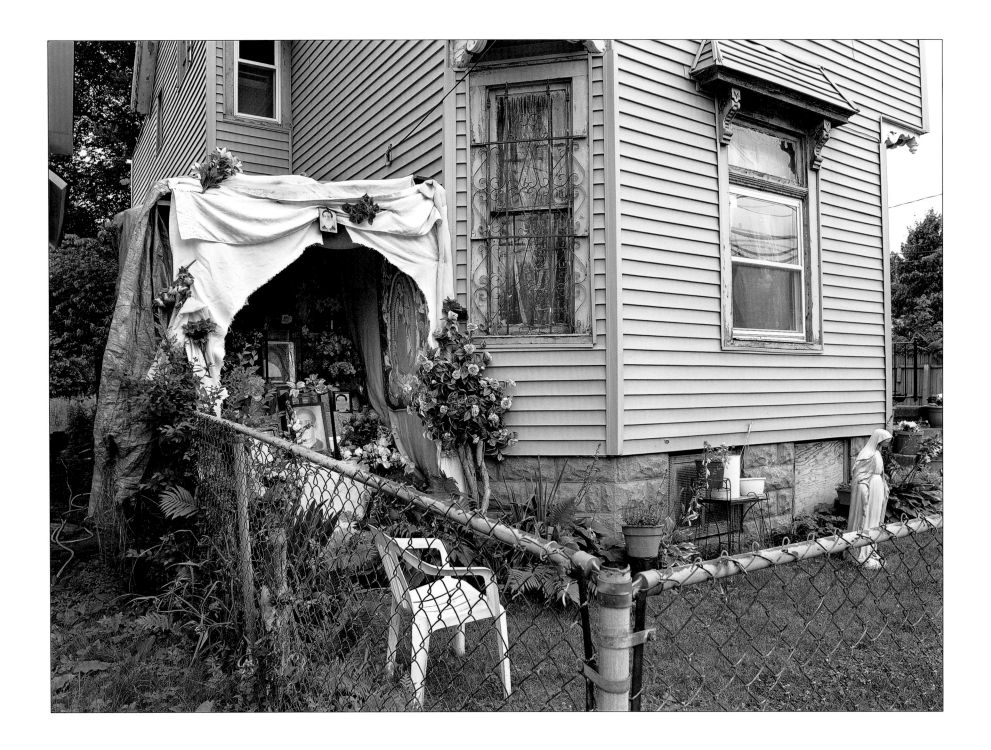

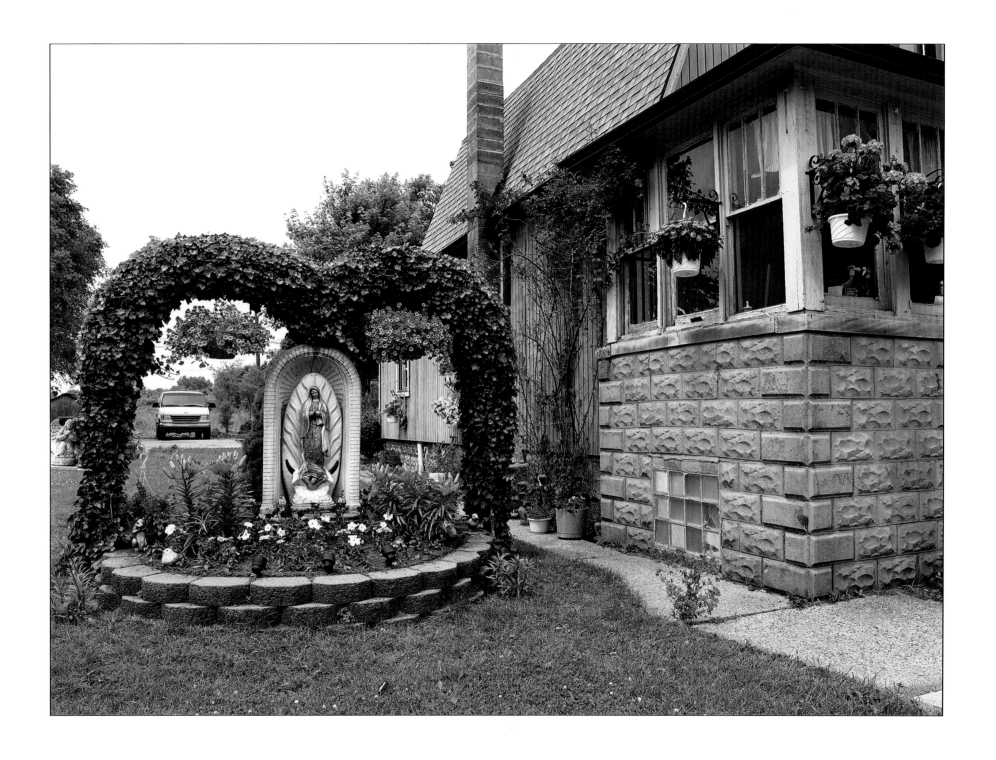

Scott Hocking grew up in the Detroit area and attended the College for Creative Studies, Detroit, receiving a BFA in 2000. In 2001 Hocking emerged onto the Detroit art scene with his first serious installation: *Relics*, a collaboration with Clinton Snider, another Detroit-based artist. Created from discards found on sites around Detroit, the installation was part of the Detroit Institute of Arts exhibition *Artists Take on Detroit* in celebration of the city's tercentenary.

For more than a decade, Hocking has continued to ground his artistic practice in the city and experiences the terrain of Detroit on foot. Working during all seasons and often in the sites of abandoned industry and ancient earthworks, he collects artifacts, creates site-specific installations, and photographs the places he encounters. Interested in the cyclical nature of civilization and history, Hocking has noted, "Wherever I go, the history and people of the place influence my artwork. I explore my surroundings for things forgotten or kept out of sight, gather information, images and materials. I'm often inspired or bothered by what I find."

# SCOTT HOCKING

Born 1975, Redford Township, Michigan

Lives in Detroit

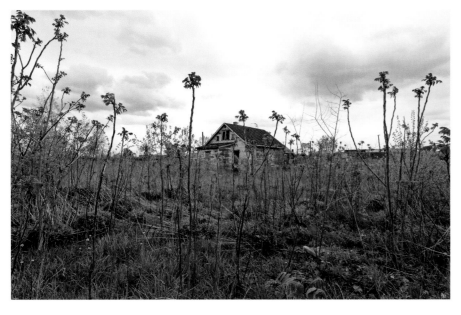

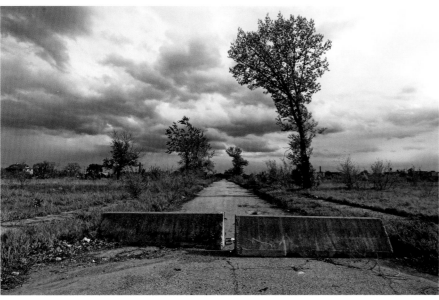

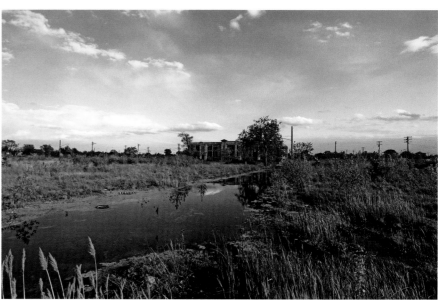

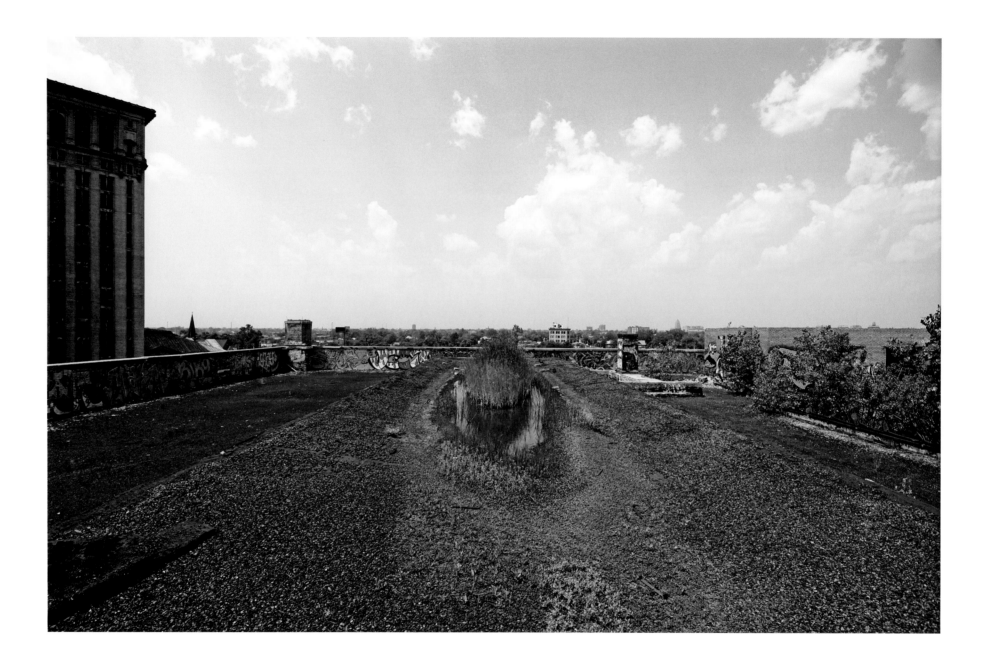

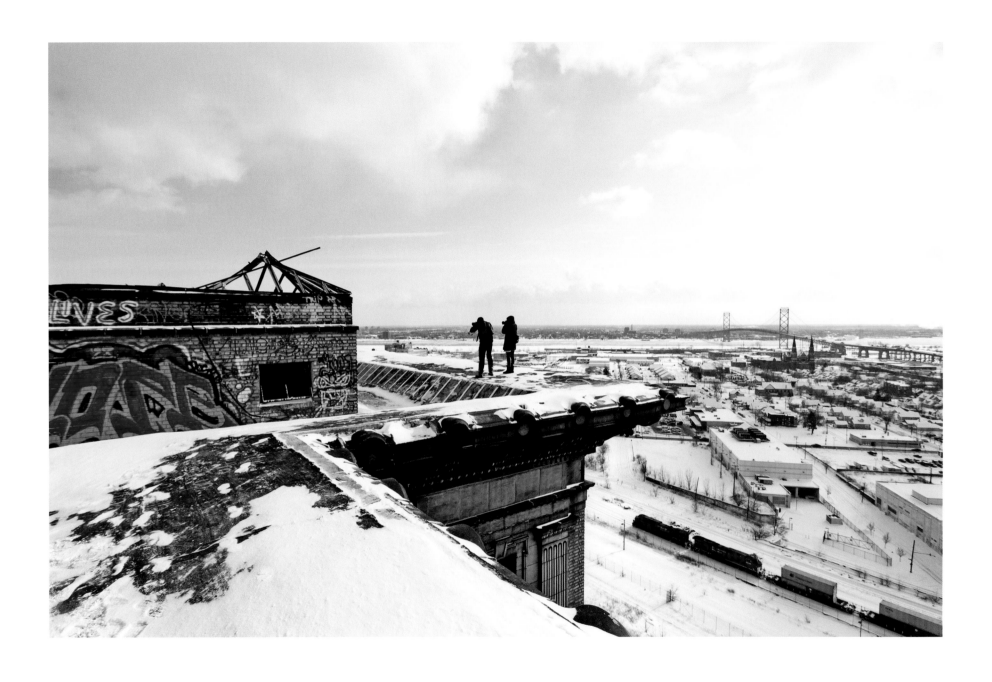

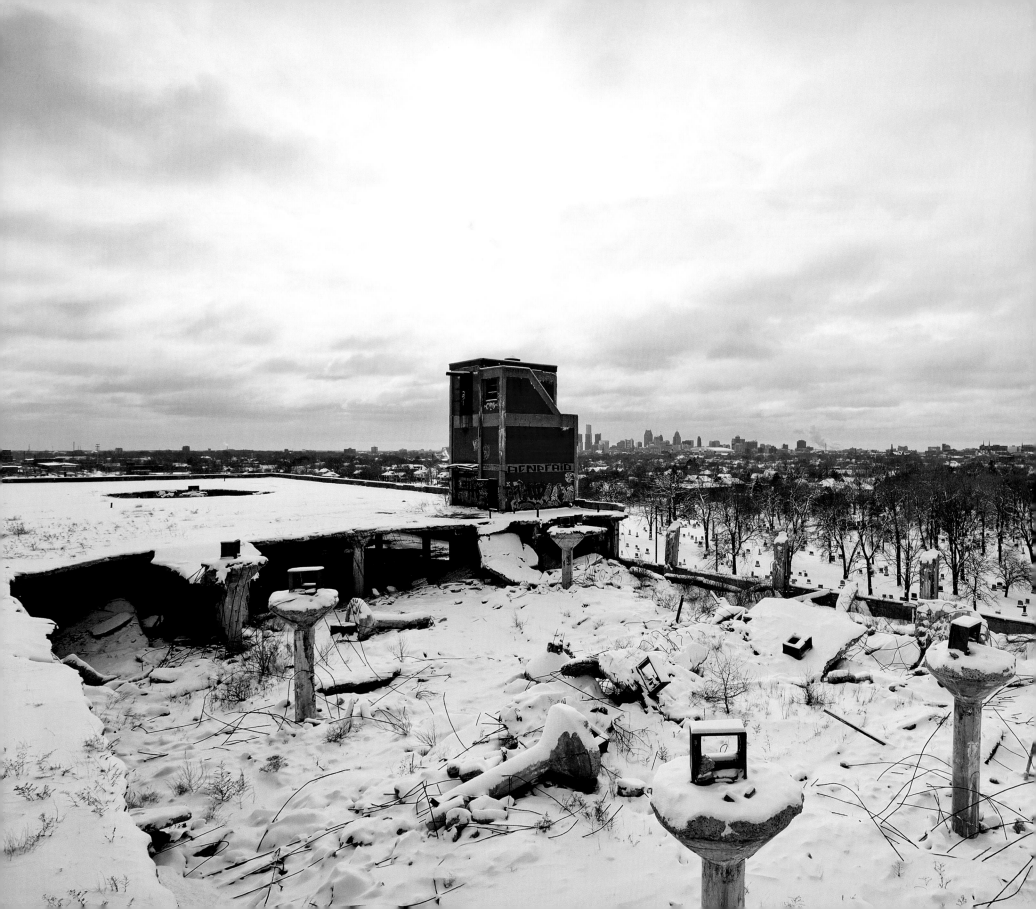

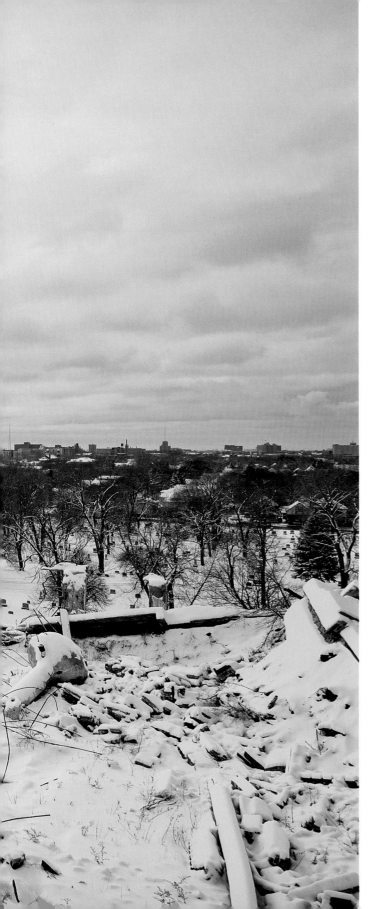

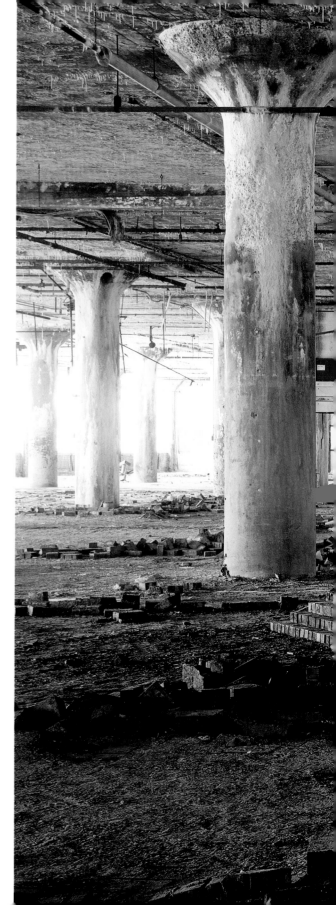

Detroit Revealed

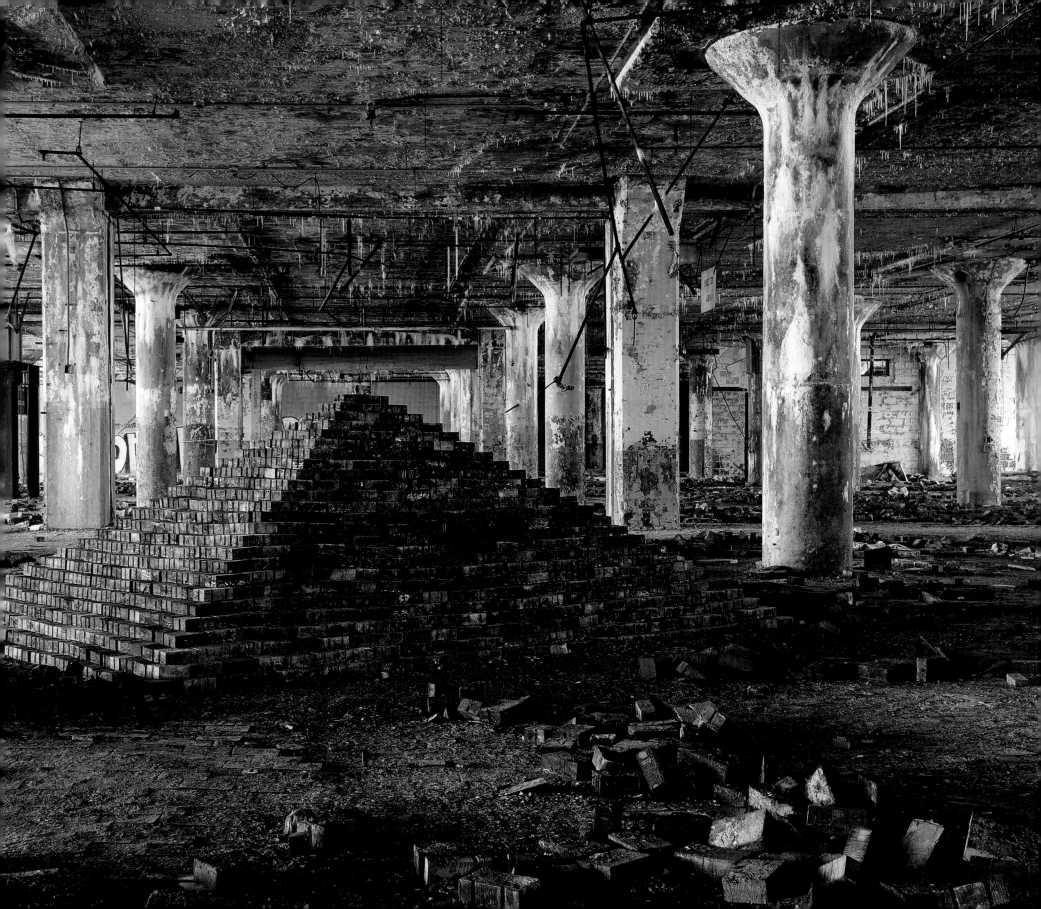

Photographer and video artist Ari Marcopoulos moved to the United States in about 1980 and became immersed in New York City's art and music scene. He was an assistant at Andy Warhol's studio, where he worked on photo shoots and as a darkroom printer for the artist. Over the years, Marcopoulos developed a close affinity with creative individuals who live outside the mainstream and frequently found himself in the company of artists, writers, and musicians, whom he often photographed.

Over the last two decades, Marcopoulos has produced a large body of work on the subject of youth culture, its social rituals, and the underground activity that emerges from music, snowboarding, skateboarding, and street art. In 2009 Marcopoulos traveled to Detroit and, through friends, met two young musicians—Hunter and Shane Muldoon. He photographed the brothers in their bedroom, also a makeshift rehearsal studio, while they experimented with audio using a barrage of foot switches, looping devices, and modulators to create a range of sound effects. During the session, Marcopoulos made *Detroit*, a seven-and-a-half minute video of the experience, as well as a series of still photographs.

Best known for working with multiples and low-grade paper and printing processes, he often creates handmade books with reproductions of his original photographs. Marcopoulos published additional work from his Detroit travels in a newsprint book featuring reproductions entitled *Detroit 2009*. He collaborated further with the Muldoons to create a limited-edition recording on vinyl for Brainfood records in 2010.

# ARI
# MARCOPOULOS

Born 1957, Amsterdam, the Netherlands

Lives in Brooklyn

1.22.09

Born 1957, Old Greenwich, Connecticut

Lives in New York City

# ANDREW
## MOORE

Andrew Moore studied photography at Princeton University and now teaches there and at the School of Visual Arts, New York City. He lives and, when not traveling, works in his New York studio. He has participated in photographic projects internationally, from New York City and Detroit, to Cuba, Russia, and, most recently, Abu Dhabi.

Moore has photographed cities in transition for more than two decades, paying particular attention to architecture, history, and, ultimately, the decline of modernism in America and throughout the world. In 2008–09, he photographed in Detroit using large-format camera equipment that resulted in large-scale color prints. His work represents an in-depth study of the city, its architecture, industrial sites, and neighborhoods.

He states that, "My photographic interests have always lain at the busy intersections of history, particularly those locations where multiple tangents of time overlap and tangle. In other places I have photographed, such as Cuba and Russia, these meanderings of time create a densely layered, historical narrative. In Detroit, the forward motion of time appears to have been thrown spectacularly into the reverse."

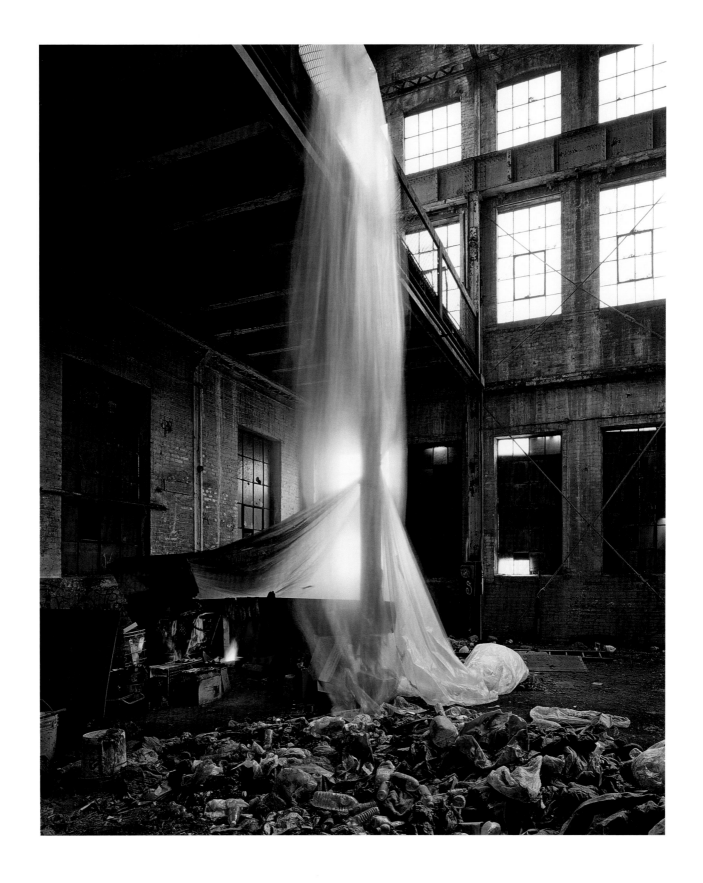

Detroit Revealed

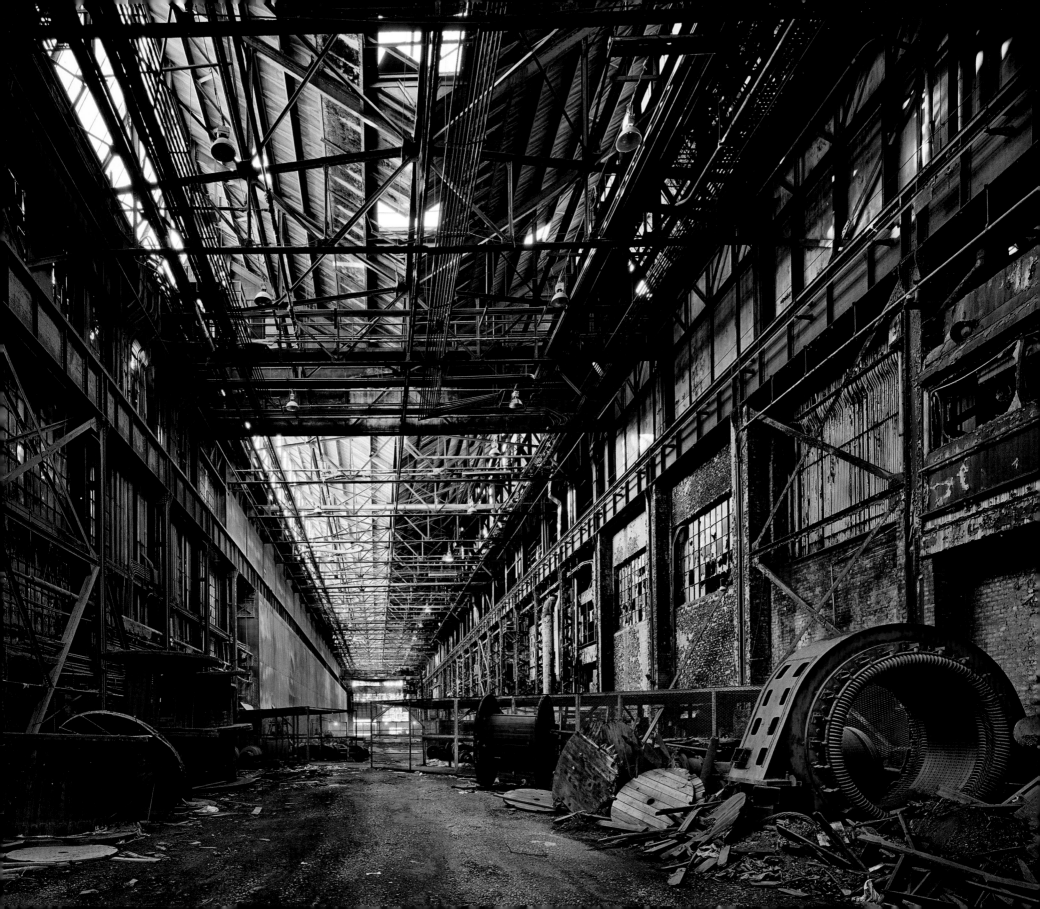

# ALEC
# SOTH

Born 1969, Minneapolis, Minnesota

Lives in Minneapolis, Minnesota

Alec Soth was born in Minneapolis where he continues to live and work. He received a BFA from Sarah Lawrence College, Bronxville, New York, in 1992. Soth has developed a photographic practice unique to the American experience and the sense of place he finds in his travels throughout the country.

Soth has commented that his work is neither a political statement nor a critique of American life. His photography grows from his own curiosity about the world. From 2000 to 2008, Soth photographed in the United States and published two books, *Sleeping by the Mississippi* (Göttingen, 2004) and *Niagara* (Göttingen, 2006), which examine regional identity through images of ordinary places and local people. During the same time, he also traveled across the country on assignment for periodicals and other publications. While working on a story about the decline of the American empire for Britain's *Telegraph Magazine*, he photographed a vast cross-section of life in the United States: small towns, vast western horizons, and Midwestern cites like Detroit, which had become notorious for its urban decay. Feeling "worn out" in the final days of the Bush administration, he looked to this body of work to produce his series *The Last Days of W.*, which marked the end of the president's eight-year term. Soth reproduced a selection of the photographs in a newspaper suggesting the fleeting nature of this particular time in history and noted "it's a passing thing."

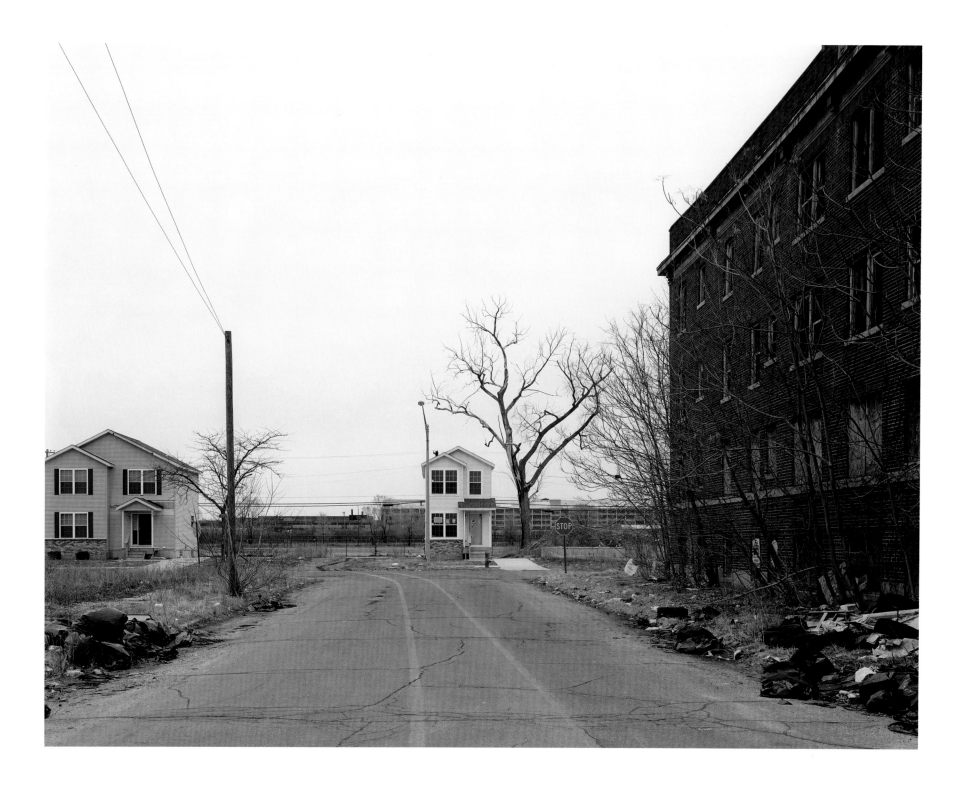

Corine Vermeulen is originally from the Netherlands, where she received a BFA in graphic design from the Design Academy Eindoven, in 2001. In 2004 she earned an MFA in photography from Cranbrook Academy of Art, Bloomfield Hills, Michigan. She settled in 2006 in Detroit, where she has photographed the city, its people, and culture.

Vermeulen's interests and the subject matter of her photographs are as diverse as the city itself. She photographs her neighbors, alternative urban lifestyles, activism, native culture, and the everyday experiences of Detroiters. She creates a picture of new life in the postautomotive era of Detroit, and for the past five years, she has worked on the series *Your Town Tomorrow*. The title is taken from a quote by former Mayor Coleman Young (1918–97), who stated, "Detroit has always been your town tomorrow…a surpassingly purposeful place as important to the nation right now as it has ever been…because right now it's telling us that cities are in trouble."

Vermeulen sees Detroit as a place filled with complex relationships between people and place that create infinite and sometimes conflicting meanings. She reveals the multifaceted nature of the city and its history through her portraits, panoramic views, and studies of urban vernacular subjects, such as hand-painted signs and murals scattered throughout the city. She noted, "Every year that I am here a new layer of reality reveals itself. You might take a picture of the outside of something and then you might actually go inside and you might find there is a person inside with a beautiful story."

# CORINE
# VERMEULEN

Born 1977, Gouda, the Netherlands

Lives in Detroit

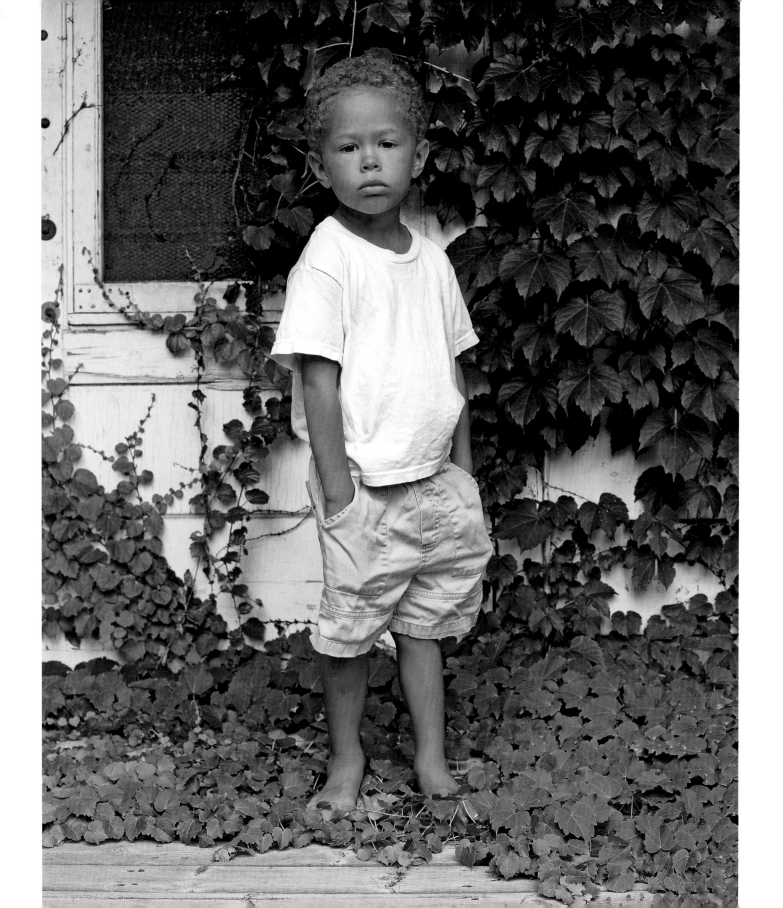

Detroit Revealed

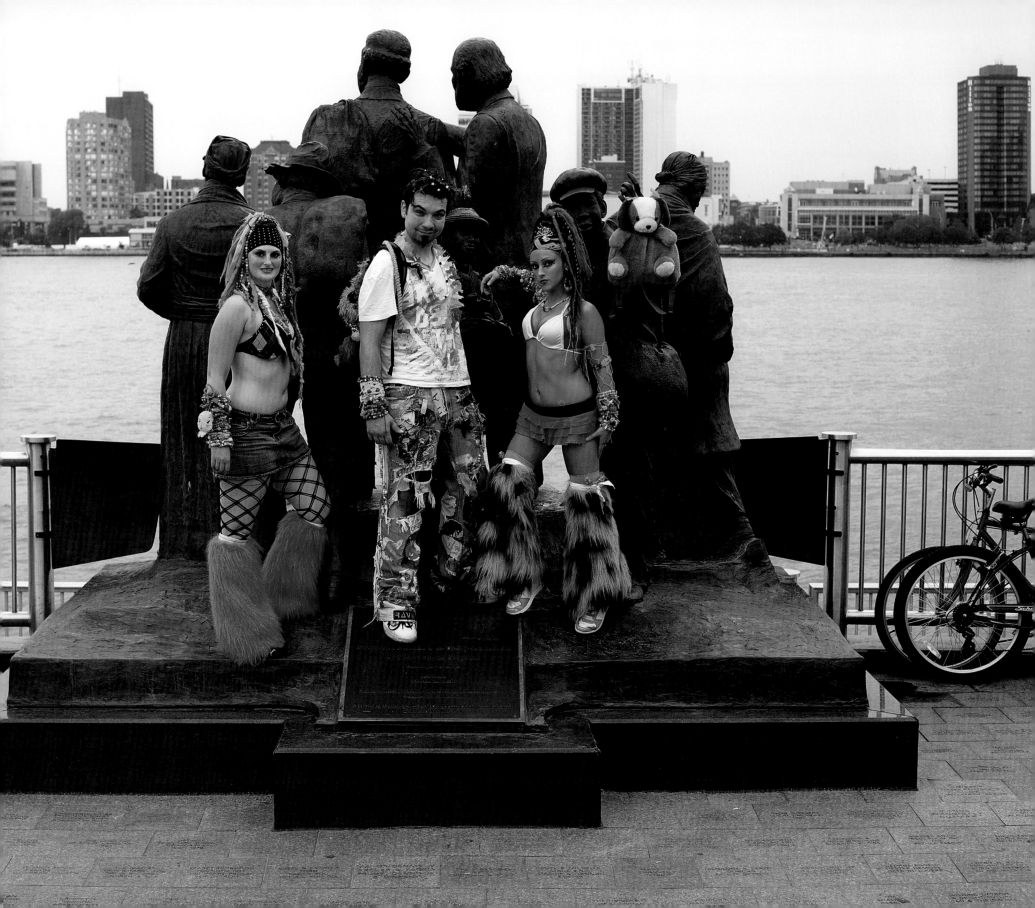

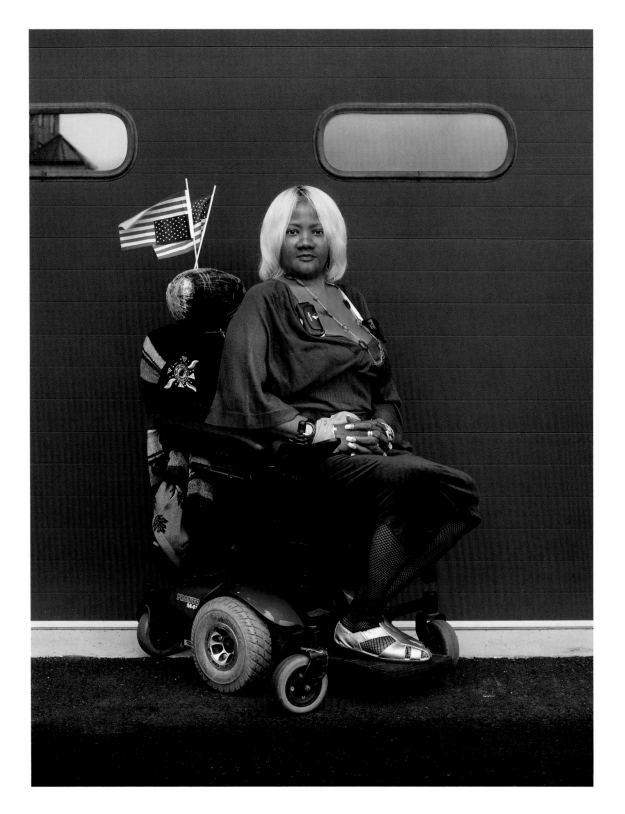

Detroit Revealed

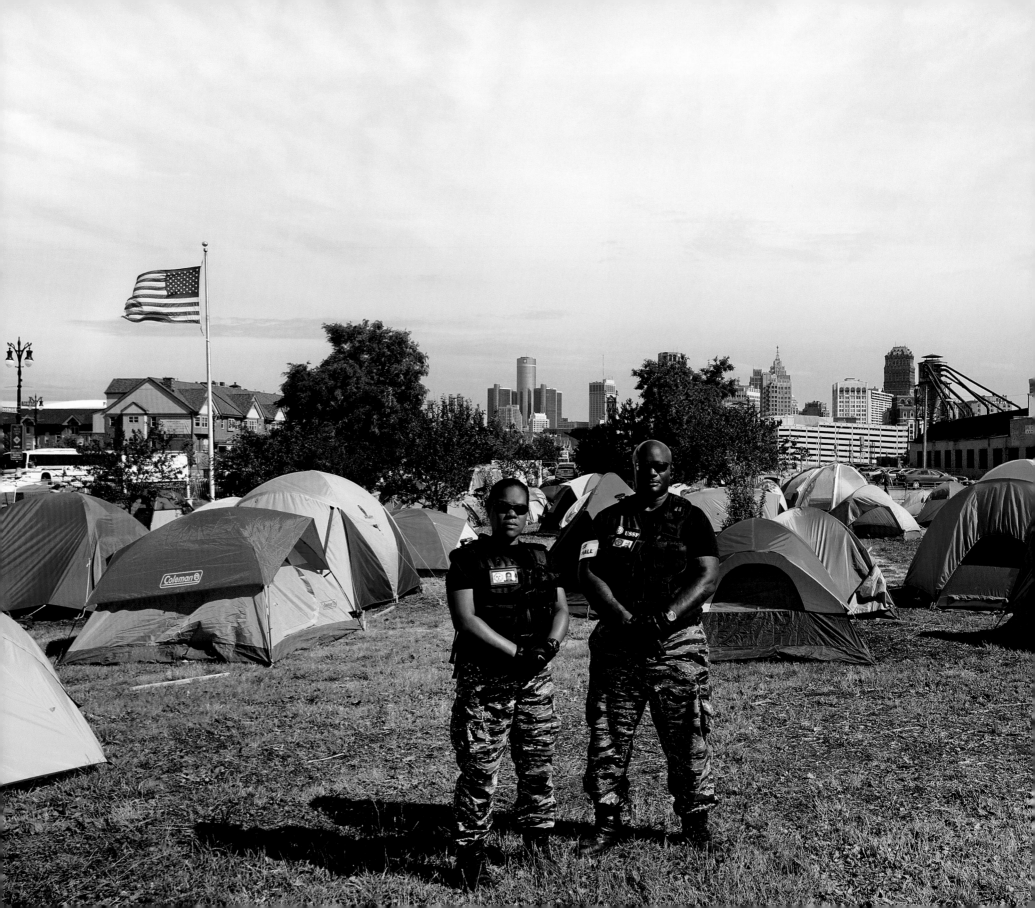

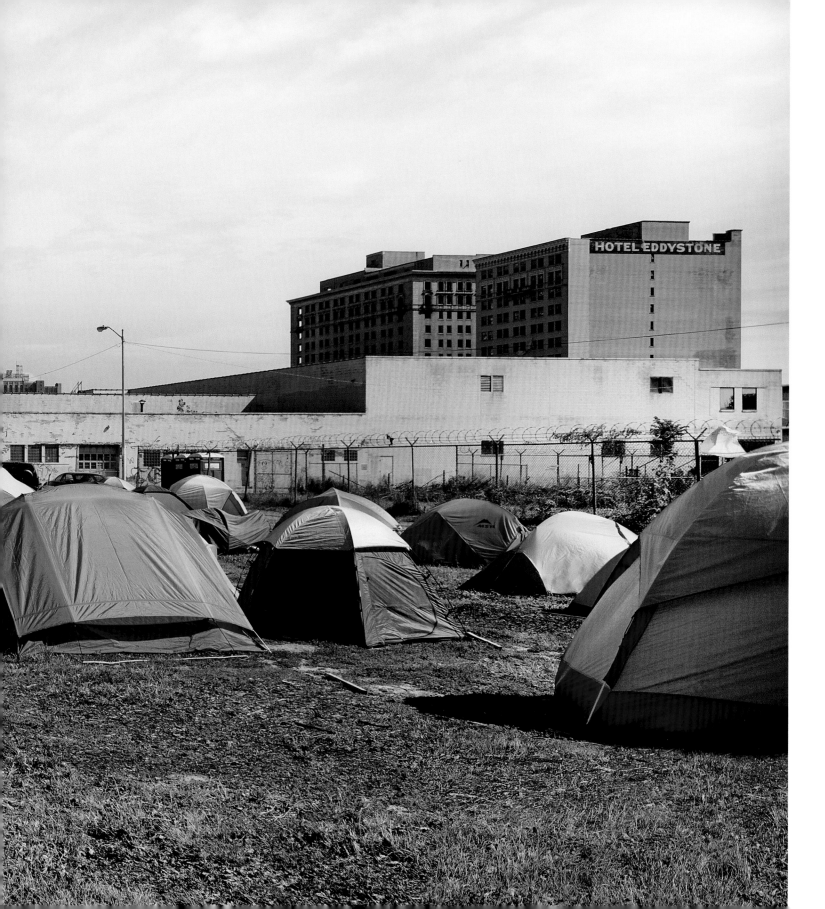

# LIST OF
# PLATES

**page 37**
Michelle Andonian, *Dearborn Assembly Plant, Melissa Coscia Works a Multi Electronic Nut Runner*, 2004 (printed in 2011), pigment print, 11⅛ x 16½ in. (27.9 x 41.9 cm). From the series *Reinvention: Rouge Photographs*. Gift of the artist in honor of Bill Rauhauser, T2011.30.8

**page 38**
Michelle Andonian, *Dearborn Assembly Plant, Final Assembly Line After Closing*, 2004 (printed in 2011), pigment print, 11⅛ x 16½ in. (27.9 x 41.9 cm). From the series *Reinvention: Rouge Photographs*. Gift of the artist in honor of Bill Rauhauser, T2011.30.10

**page 39**
Michelle Andonian, *End of the Frame Line*, 2004 (printed in 2011), pigment print, 40 x 50 in. (101.6 x 127 cm). Gift of the artist in honor of Bill Rauhauser, T2011.82

DAWOUD BEY

**page 41**
Dawoud Bey, *Yahmáney, Chadsey High School, Detroit*, 2003, chromogenic print, 50 x 40 in. (127 x 101.6 cm). Museum Purchase, Dawoud Bey Exhibition Funds, 2004.46

**page 43**
Dawoud Bey, *Gheorghina, Chadsey High School, Detroit*, 2003, chromogenic print, 40 X 50 in. (101.6 x 127 cm). Museum Purchase, Dawoud Bey Exhibition Funds, 2004.45

CARLOS DIAZ

**page 45**
Carlos Diaz, *Untitled*, 2010, pigment print, 20 x 26¾ in. (50.8 x 67.9 cm). From the series *Beyond Borders: Latino Immigrants and Southwest Detroit*. Museum Purchase, Albert and Peggy de Salle Charitable Trust, T2011.16.11

**page 46, left**
Carlos Diaz, *Juan Flores Almanza*, 2010, pigment print, 21⅝ x 21⅝ in. (54.9 x 54.9 cm). From the series *Beyond Borders: Latino Immigrants and Southwest Detroit*. Museum Purchase, Albert and Peggy de Salle Charitable Trust, T2011.16.1

**page 46, middle**
Carlos Diaz, *Maria Diaz*, 2010, pigment print, 21⅝ x 21⅝ in. (54.9 x 54.9 cm). From the series *Beyond Borders: Latino Immigrants and Southwest Detroit*. Museum Purchase, Albert and Peggy de Salle Charitable Trust, T2011.16.3

**page 46, right**
Carlos Diaz, *Gabriel Arteaga*, 2010, pigment print, 21⅝ x 21⅝ in. (54.9 x 54.9 cm).  From the series *Beyond Borders: Latino Immigrants and Southwest Detroit*. Museum Purchase, Albert and Peggy de Salle Charitable Trust, T2011.16.4

**page 47, left**
Carlos Diaz, *Karina Rubio*, 2010, pigment print, 21⅝ x 21⅝ in. (54.9 x 54.9 cm). From the series *Beyond Borders: Latino Immigrants and Southwest Detroit*. Gift of the artist, T2011.16.6

**page 47, middle**
Carlos Diaz, *Martin Lozano*, 2010, pigment print, 21⅝ x 21⅝ in. (54.9 x 54.9 cm). From the series *Beyond Borders: Latino Immigrants and Southwest Detroit*. Museum Purchase, Albert and Peggy de Salle Charitable Trust, T2011.16.5

**page 47, right**
Carlos Diaz, *Andrea Medina*, 2010, pigment print, 21⅝ x 21⅝ in. (54.9 x 54.9 cm). From the series *Beyond Borders: Latino Immigrants and Southwest Detroit*. Museum Purchase, Albert and Peggy de Salle Charitable Trust, T2011.16.2

**page 48**
Carlos Diaz, *Untitled*, 2010, pigment print, 20 x 26¾ in. (50.8 x 67.9 cm). From the series *Beyond Borders: Latino Immigrants and Southwest Detroit*. Gift of the artist, T2011.16.12

**page 49**
Carlos Diaz, *Untitled*, 2010, pigment print, 20 x 26¾ in. (50.8 x 67.9 cm). From the series *Beyond Borders: Latino Immigrants and Southwest Detroit*. Museum Purchase, Albert and Peggy de Salle Charitable Trust, T2011.16.7

## SCOTT HOCKING

**page 51, top left**
Scott Hocking, *Baby Palms, Spring,* 2009 (printed in 2010), pigment print, 14½ x 22 in. (36.8 x 55.9 cm). From the series *The Zone,* 1999–2010. Museum Purchase, Coville Photographic Fund, 2010.38.11

**page 51, top right**
Scott Hocking, *Concord Couch, Summer,* 2008 (printed in 2010), pigment print, 14½ x 22 in. (36.8 x 55.9 cm). From the series *The Zone,* 1999–2010. Museum Purchase, Coville Photographic Fund, 2010.38.2

**page 51, bottom left**
Scott Hocking, *Winfield South, Spring,* 2009 (printed in 2010), pigment print, 14½ x 22 in. (36.8 x 55.9 cm). From the series *The Zone,* 1999–2010. Museum Purchase, Coville Photographic Fund, 2010.38.3

**page 51, bottom right**
Scott Hocking, *Concord Swamp Swift, Spring,* 2009 (printed in 2010), pigment print, 14½ x 22 in. (36.8 x 55.9 cm). From the series *The Zone,* 1999–2010. Museum Purchase, Coville Photographic Fund, 2010.38.9

**page 52**
Scott Hocking, *Roof Marsh,* 2008 (printed in 2009), pigment print, 22 x 33 in. (55.8 x 83.8 cm). From the series *Roosevelt Warehouse and the Cauldron,* 2007–11. Museum Purchase, DeRoy Photographic Acquisition Endowment Fund, 2009.46

**page 53**
Scott Hocking, *Southeast from Roof, Michigan Central,* 2009 (printed in 2010), pigment print, 20 x 30 in. (50.8 x 76.2 cm). From the series *The Egg and MCTS,* 2007–11. Gift of the artist, Scott Hocking and Susanne Hilberry Gallery, 2010.64

**pages 54–55**
Scott Hocking, *Garden of the Gods, South, Winter,* 2009 (printed in 2010), pigment print, 33 x 49½ in. (83.8 x 125.7 cm). From the series *Garden of the Gods,* 2009–10. Gift of the artist, Scott Hocking and Susanne Hilberry Gallery, 2010.63

**pages 56–57**
Scott Hocking, *Ziggurat—East, Summer,* 2008 (printed in 2009), pigment print, 22 x 33 in. (55.8 x 83.8 cm). From the series *Ziggurat and FB21,* 2007–9. Museum Purchase, DeRoy Photographic Acquisition Endowment Fund, 2009.45

## ARI MARCOPOULOS

**page 59**
Ari Marcopoulos, *Detroit #1,* 2010, pigment print, 18¾ x 28 in. (47.6 x 71.2 cm). Museum Purchase, DeRoy Photographic Acquisition Endowment Fund, 2010.41

## ANDREW MOORE

**page 61**
Andrew Moore, *Shelter, Engine Works, Detroit Dry Dock Company, Rivertown Neighborhood,* 2009, pigment print, 57 x 45⅜ in. (144 x 115 cm). Museum Purchase, Albert and Peggy de Salle Charitable Trust, 2010.33

**pages 62–63**
Andrew Moore, *Rolling Hall, Ford Motor Company, River Rouge Complex,* 2008 (printed in 2009), chromogenic print, 62 x 78 in. (157 x 198 cm). Museum Purchase, Albert and Peggy de Salle Charitable Trust, 2010.32

## ALEC SOTH

**page 65**
Alec Soth, *Detroit, Michigan (Small house at the end of the road),* 2008, pigment print, 24 x 30 in. (61 x 76.2 cm). From the series *The Last Days of W.* Museum Purchase, Albert and Peggy de Salle Charitable Trust Fund, 2009.42

**page 67**
Corine Vermeulen, *William,* 2010 (printed in 2011), pigment print,
30 x 22½ in. (76.2 x 57.1 cm). From the series *Your Town Tomorrow.*
Museum Purchase, Albert and Peggy de Salle Charitable Trust, T2011.29.3

**page 68**
Corine Vermeulen, *Palm Trees, L.A. Coney Family Restaurant,* 2010 (printed
in 2011), pigment print, 30 x 22½ in. (76.2 x 57.1 cm). From the series *Your
Town Tomorrow.* Museum Purchase, Albert and Peggy de Salle Charitable
Trust, T2011.29.7

**pages 68–69**
Corine Vermeulen, *Dana, Mr. Busy, Fae/International Underground Railroad
Memorial,* 2010 (printed in 2011), pigment print, 30 x 40 in. (76.2 x 101.6
cm). From the series *Your Town Tomorrow.* Museum Purchase, Albert and
Peggy de Salle Charitable Trust, T2011.29.6

**page 70**
Corine Vermeulen, *Emily,* 2010 (printed in 2011), pigment print, 30 x 22½ in.
(76.2 x 57.1 cm). From the series *Your Town Tomorrow.* Museum Purchase,
Albert and Peggy de Salle Charitable Trust, T2011.29.2

**page 71**
Corine Vermeulen, *Obama Mural, Mugshot Bar & Grill,* 2009 (printed in
2011), pigment print, 30 x 22½ in. (76.2 x 57.1 cm). From the series *Your
Town Tomorrow.* Museum Purchase, Albert and Peggy de Salle Charitable
Trust, T2011.29.1

**pages 72–73**
Corine Vermeulen, *U.S. Social Forum Camp Grounds and Security Guards,*
2010 (printed in 2011), pigment print, 30 x 60 in. (76.2 x 152.4 cm). From the
series *Your Town Tomorrow.* Museum Purchase, Albert and Peggy de Salle
Charitable Trust, T2011.29.5

Akron Art Museum. *Detroit Disassembled: Photographs by Andrew Moore*. Edited by Barbara Tannenbaum. Akron, OH, 2010.

Austin, Dan, and Sean Doerr. *Lost Detroit: Stories Behind the Motor City's Majestic Ruins*. Charleston, SC, 2010.

Barr, Nancy. "Truth, Memory and the American Working-Class City: Robert Frank in Detroit and at the Rouge," *Bulletin of the Detroit Institute of Arts*, 76, nos. 1–2 (2002): 62–74.

———. *Detroit Experiences: Robert Frank Photographs, 1955*. Exh. brochure, The Detroit Institute of Arts. Detroit, 2010.

Bailey, III, J. E. *The City Within: Photographs by J. Edward Bailey III*. Exh. cat., The Detroit Institute of Arts. Detroit, 1969.

Bey, Dawoud. *Class Pictures*. Edited by Nancy Grubb. New York, 2007.

Bonami, Francesco, and Gary Carrion-Murayari. "Ari Marcopoulos," 80–81. In *2010: Whitney Biennial*. Exh. cat., Whitney Museum of American Art. New York, 2010.

Bukowczyk, John J., and Douglas Aikenhead. *Detroit Images: Photographs of the Renaissance City*. Detroit, 1989.

Desjarlais, Mary. *Bill Rauhauser: 20th Century Photography in Detroit*. Livonia, MI, 2010.

# SELECTED
# BIBLIOGRAPHY

Esche, Charles, Kerstin Niemann, and Stephanie Smith. "Scott Hocking." In *Heartland*. Exh. cat., Van Abbemuseum, Eindhoven, The Netherlands; Smart Museum of Art, Chicago. Chicago, 2009.

Evans, Walker. "Labor Anonymous." *Fortune* (November 1946): 152–53.

Frank, Robert. *The Americans*. New York, 1959.

Hixson, Kathryn. "An interview with Stan Douglas." *New Art Examiner* 28, no. 4 (December 2000/January 2001): 22–26.

Jacob, Mary Jane, and Linda Downs. *The Rouge: The Image of Industry in the Art of Charles Sheeler and Diego Rivera*. Exh. cat., The Detroit Institute of Arts. Detroit, 1978.

Marchand, Yves, Romain Meffre, and Robert Polidori. *The Ruins of Detroit*. Göttingen, 2010.

Marcopoulos, Ari. *Detroit 2009*. New York, 2009.

Matutschovsky, Natalie, and Corine Vermeulen. "Photo Essay: Teen Moms in Detroit: Fighting to Save the School that Saved Them," TIME LightBox, accessed May 31, 2011, http://lightbox.time.com/2011/05/12/teen-moms-in-detroit-fighting-to-save-the-school-that-saved-them/#1.

Moore, Andrew. "Urban Archaeology: Photographs and Commentary by Andrew Moore." *Aperture* 197 (winter 2009): 46–51.

Ryzik, Melena. "Wringing Art Out of the Rubble in Detroit." *The New York Times*, accessed August 4, 2010, http://www.nytimes.com/2010/08/04/arts/design/04maker.html?pagewanted=1.

Schulz, Constance B. *Michigan Remembered: Photographs from the Farm Security Administration and the Office of War Information, 1936–1943*. Detroit, 2001.

Shea, Daniel. "Interview: Alec Soth." Toomuchchocolate, accessed May 19, 2011, http://toomuchchocolate.org/?p=1067.

Siegel, Arthur. *America from the Great Depression to World War II: Black-and-White Photographs from the FSA-OWI, 1935–1945*. Library of Congress, accessed May 31, 2011, http://www.loc.gov/search/?q=arthur+s.+siegel+detroit+michigan&fa=digitized%3Atrue&sp=2.

Soth, Alec. *The Last Days of W*. St. Paul, 2008.

Soth, Alec. "The Last Days of W." *Modern Painters* 20, no. 8 (October 2008): 80–85.

Stebbins, Jr., Theodore E., Gilles Mora, and Karen E. Haas. *The Photography of Charles Sheeler: American Modernist*. Boston, 2002.

Tower, Tim. "An Interview with Photographer Andrew Moore, Author of *Detroit Disassembled*." *World Socialist Web Site*, accessed May 2, 2011, http://www.wsws.org/articles/2011/jan2011/inte-j05.shtml.

Vergara, Camilo J. *American Ruins*. New York, 1999.

Detroit Revealed